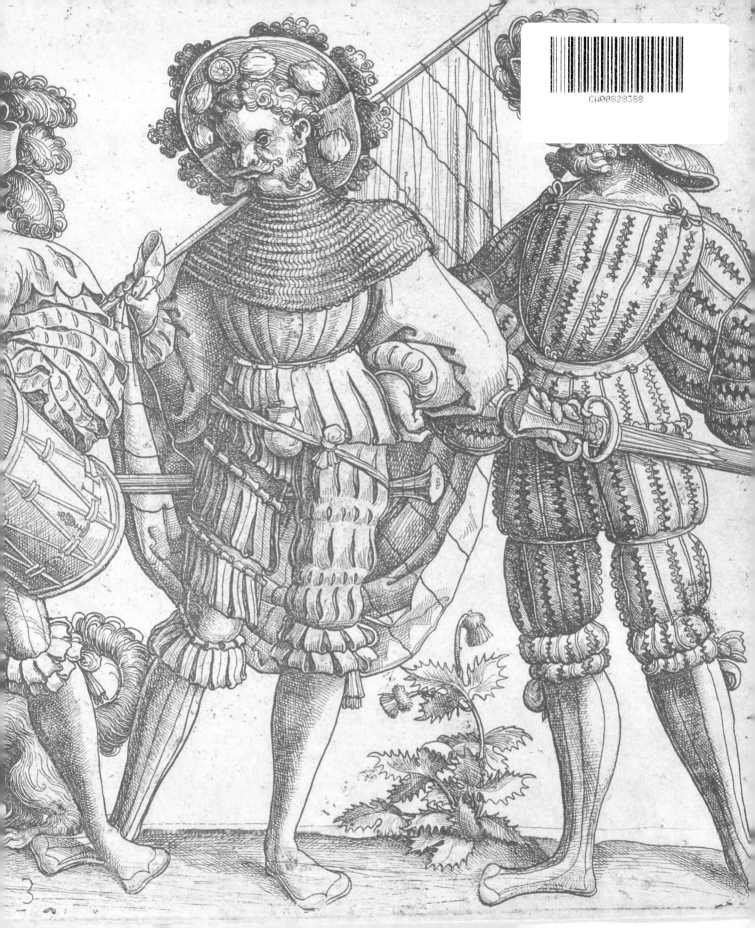

Fashion and Armour
in Renaissance Europe

Fashion and Armour in Renaissance Europe

Proud Lookes and Brave Attire

Angus Patterson

V&A Publishing

First published by V&A Publishing, 2009
V&A Publishing
Victoria and Albert Museum
South Kensington
London SW7 2RL

Distributed in North America by Harry N. Abrams, Inc., New York

Hardback edition
ISBN 978 1 85177 581 1
Library of Congress Control Number 2009923084
10 9 8 7 6 5 4 3 2 1
2013 2012 2011 2010 2009

Designer: Andrew Shoolbred
Copy-editor: Rachel Malig
Indexer: Vicki Robinson

New V&A photography by Richard Davis, Christine Smith and Pip Barnard, V&A Photographic Studio

Front jacket illustration: 'My Lord Bucarte', from the *Almain Armourer's Album*, pl.11
Back jacket illustration: Francesco Il della Rovere, pl.40
Half-title: Lucio Foppa, pl.39
Title page: A Tournament at Brescia in the Piazza Maggiore, pl.7
Contents: Infantry helmet (morion), pl.43

Printed in Singapore

V&A Publishing
Victoria and Albert Museum
South Kensington
London SW7 2RL
www.vam.ac.uk

Contents

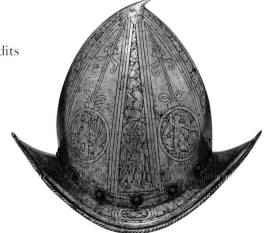

Timeline 1480–1620

1480–1500

Slender upwards proportion, emphasis on long legs, high waistline, small skirt tabs on doublet and breastplate, with decorative trim, piked (pointed) shoes

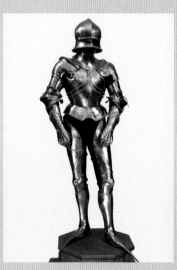

Armour for the future Emperor Maximilian I, made by Lorenz Helmschmid, Augsburg, c.1484
(Hofjagd- und Rüstkammer, Vienna, A.62)

Detail of an English prince from a tapestry depicting the Alsatian story of 'The Buzzard', Strasbourg, c.1480
(V&A 4509-1858)

1500–50

Broad 'horizontal' proportion, wide shoulders, vertical pleats, 'winged' neckline, pinched waist with billowing skirt/hose, puffed sleeves, square shoes, tight stockings below knee

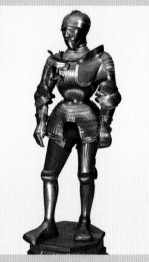

Armour of Ulrich von Württemberg, made by Wilhelm von Worms, Nuremberg, 1525–30
(Hofjagd- und Rüstkammer, Vienna, A.237)

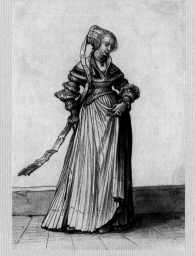

Middle class woman from Basel, Switzerland, around 1520, by the artist Hans Holbein
(Kunstmuseum Basel, Kupferstichkabinett, Basel)

1550–70

Figure-hugging upper body with bands of decoration outlining shape, short skirted doublet, knee-length tassets and hose, straight shoes

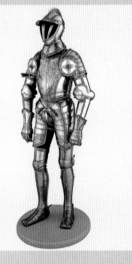

Armour of Emperor Ferdinand I, made by Kunz Lochner, Nuremberg, dated 1549

(Metropolitan Museum, New York, 33.164a–x)

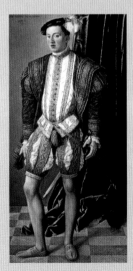

Portrait of Archduke Ferdinand II of Tyrol by Jakob Seisenegger, 1548

(Kunsthistorichesmuseum, Vienna)

1570–90

Pronounced pointed breastplate/doublet, high trunk hose and tassets, highly decorated surfaces, long, slender emphasis on lower body

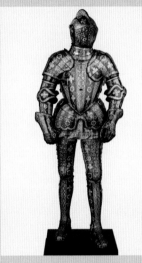

Armour of George Clifford, 3rd Earl of Cumberland, made in the Royal workshop in Greenwich, England, 1580–85

(Metropolitan Museum, New York Munsey Fund, 1932, 32.130.6)

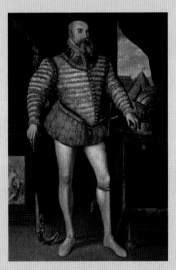

Portrait of Robert Dudley, Earl of Leicester, artist unknown, 1575

(Parham Park)

1590–1620

Full-bodied, short, square upper body, falling band on helmet and lace collar, emphasis on high waistline, bulging thighs, tapering legs, knee-length boots

Cuirassier (horseman's) armour, Germany or the Netherlands, 1625–30

(Royal Armouries, Leeds, II.140)

Portrait of James Hamilton, 2nd Marquess of Hamilton by Daniel Mytens 1624–5

(English Royal Collection)

Introduction

The young prince gazes haughtily from the canvas (see plate 1). He stands in front of rich velvet hangings that catch the light and bathe him in a golden glow. His face is framed by an intricate linen ruff, his hands by matching cuffs. His costly black velvet breeches are cut in vertical panes and embroidered in silver threaded zigzags. But the clothing he most wants us to see is made of steel. His breastplate protrudes fashionably at the belly and is decorated with etched bands infilled with gold vines and leaves. The gold contrasts starkly with the deep blue heat-treated steel that glistens in the light. Tassets covering his hips continue this decorative scheme, as do the pauldrons on his shoulders and the vambraces on his arms. Leaning languidly against the table, he looks perfectly at ease in his armour.

From the velvet sling that matches his breeches hangs his sword at his left hip. A dagger shows from behind his back. Their blades are hidden for it is their decorated hilts he wants us to see. The prince is not equipped for battle; he is dressed for fashion. He is a man of great wealth and taste, deeply image-conscious and aware of his nobility. This is how he wants to be remembered.

Of all the riches of the Renaissance nobleman, none spoke more powerfully of his honour and standing than his armour and weapons. Pragmatism might suggest that good armour should be shaped with protection only in mind, that it should strike a balance between being thick enough to protect against sword blows, lance strikes and musket-shot, and light enough to allow for fast movement. Armour, however, even for fighting, can be dated according to shape, proportion and decoration as effectively as clothing; changes in fashion affected the

OPPOSITE
Pl.1, 'Prince Philip Emmanuel of Savoy', c.1604, Juan Pantoja de la Cruz, Spain, oil on canvas, 111.5 x 89.5cm, Museo de Bellas Artes, Bilbao, 94/119

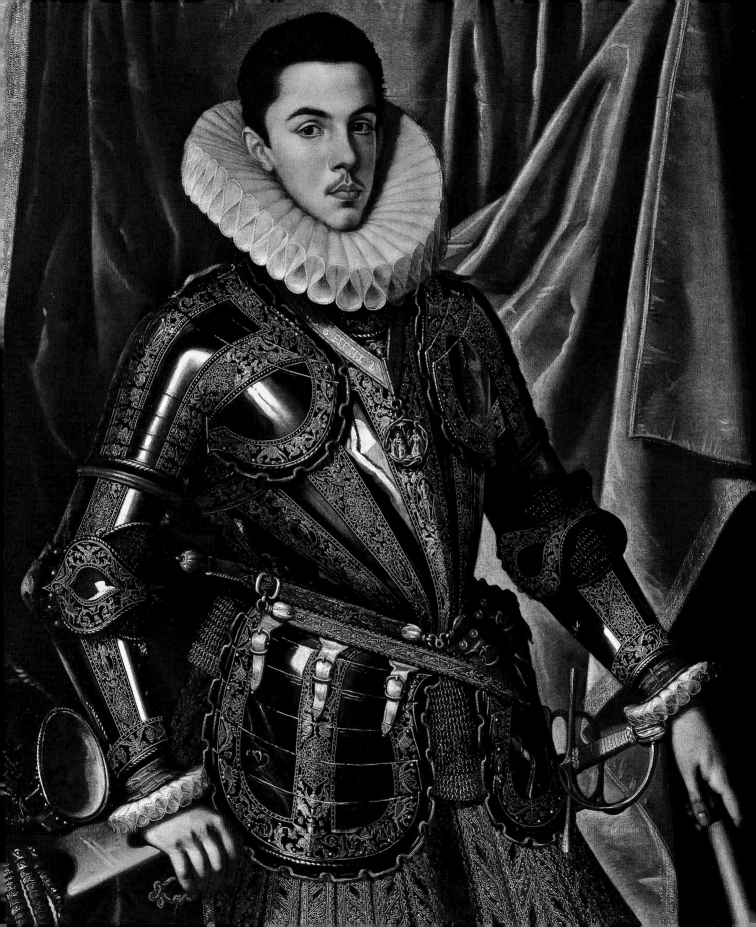

ways men presented themselves, whether they chose to dress in leather, satin, velvet or steel. Armour *was* clothing.

Depictions of great events in paintings, tapestries and sculpture suggest armour played a central role in visual as well as political culture. Parade armours, lavishly ornamented with figures from classical mythology, decorated with plumes of ostrich feathers and draped with colourful silk sashes, created an aura of luxury and majesty. Their owners, who might only commission one or two such armours in a lifetime, aimed to inspire awe through their appearance.

Noblemen also commissioned weapons both as instruments of power and as works of art. Forged and ornamented by the most skilled craftsmen, weapons were status symbols whose first and sometimes only impact was visual. While most weapons were certainly not benign, they were, during the sixteenth century, increasingly worn as dress accessories. Swords, daggers, breastplates, shields, hunting tools, guns and gunpowder flasks were decorated using the same motifs that were chosen for tapestries, furniture, silver and ceramics. Some pieces were designed to kill, others to protect. Most were designed to intimidate, and all were created to impress (see plate 2).

This book takes a fresh look at an often ignored element of fashion history. Seeing armour as clothing and weapons as accessories allows us to put an often misconstrued subject into context. One only has to look at the great riches in Renaissance collections to see the importance of armour and weapons to the image of the nobleman. And armouries were fashion accessories in themselves: those in the princely palaces in Madrid, Dresden, Prague, Paris and London served not only as storehouses ready for war, but as showcases designed to fill visiting dignitaries with wonder. They were the treasure houses of powerful families, visible symbols of their authority and memorials to their heroic pasts.

Pl.2, Gunpowder flask, *c.*1600, Austria, antler carved in relief with Adam and Eve after an engraving by Albrecht Dürer and mounted in silver-gilt, 27 x 11.5cm, V&A: 234-1854

Myths and Realities

Armour is frequently misunderstood. It is difficult to imagine the drama, excitement, noise, fear, awe and grandeur it once evoked; 'heavy', 'cumbersome', 'immobile' and 'robotic' are accusations frequently hurled at its thankfully thick skin. Laurence Olivier didn't help matters when his 1944 production of *Henry V* ridiculed the clumsily clad French knights by having them hoisted onto their horses by a crane. This one piece of theatre entered the popular imagination to such an extent that it is still repeated today.

The reality is somewhat different. A full battle armour weighed around 25kg, a parade armour less. Far from trapping its wearer into immobility, its articulated plates made it highly flexible and distributed this weight around the body. In 1509 the Spanish master-of-arms, Pietro Monte, wrote that all armour should have three basic qualities: lightness, security and freedom of movement (see plates 3 & 4).[1] It took practice to be comfortable in armour, to deal with overheating and with shifts in weight as the body moved, but the fighting man did not need to be lifted onto his horse: he could run, sit, twist and, if so inclined, perform cartwheels. Shakespeare not only had Sir Richard Vernon marvelling at the spectacular image of the fully armoured prince, but also at his agility:

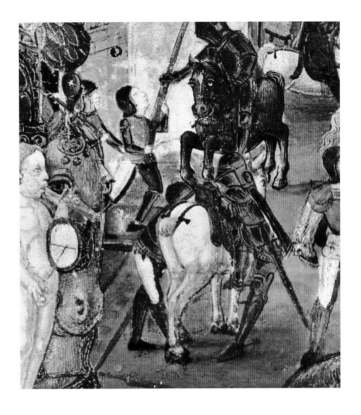

Pl.3, Manuscript detail showing an armoured man mounting a horse, probably 1477, Christophoro da Preda (1486), Milan, Italy, gouache on vellum, Wallace Collection, M342

> *I saw young Harry, with his bever on,*
> *His cuisses on his thighs, gallantly arm'd*
> *Rise from the ground like feather'd Mercury,*
> *And vaulted with such ease into his seat,*
> *As if an angel dropp'd down from the clouds.*[2]

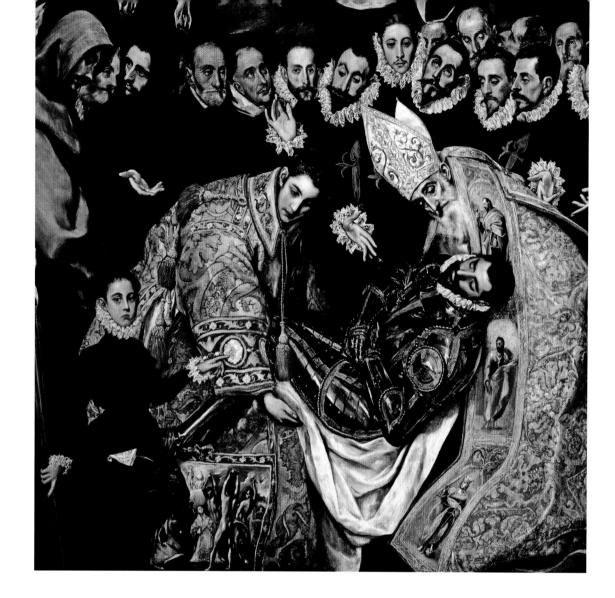

Pl.4, 'The Burial of Count Orgaz' (detail), Doménicos Theotokópoulos (known as El Greco), 1586–8, Spain, oil on canvas, 480 x 360cm, Iglesia de Santo Tomé, Toledo. The figure-hugging flexibility of good armour is amply demonstrated.

The clunky stereotype descends from the displays mounted by Regency and Victorian collectors in the Great Halls of medieval-revival country houses. These arrangements often consisted of symmetrical 'trophies' of shields with swords radiating from them like sunrays. Guarding doorways and niches were stiffly posed 'knights' sometimes assembled from several armours, whose missing parts might be replaced with new ones for effect. In Victorian interiors the armoury performed a similar role to the eighteenth-century sculpture gallery and conveyed much of the same silent formality (see plate 5).[3]

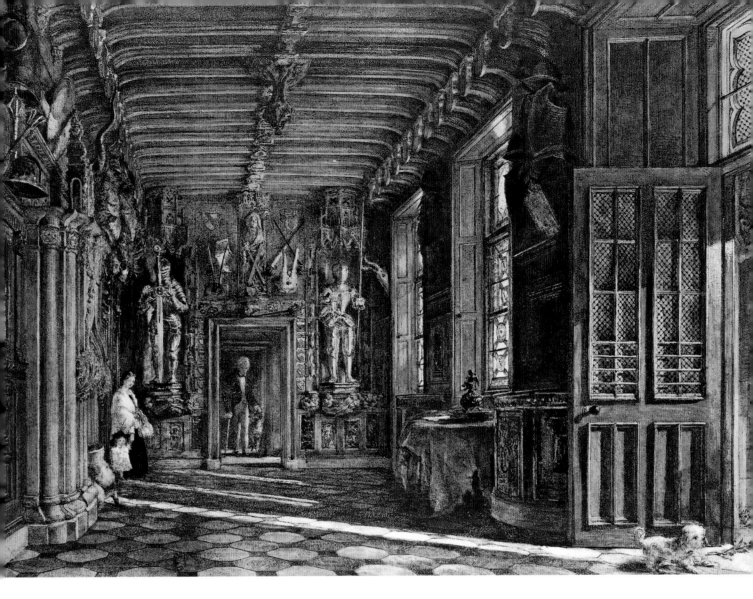

Displays of armour in museums, castles and historic houses sometimes continue this approach today. Seeing armours of varying periods propped up side by side in identical, hulking poses makes it easy to forget that these are the embodiments of actual men, each with his own posture and bearing. Few armours survive fully intact with all their 'furniture' and decoration. Most have lost their accompanying colourful sashes, plumes, fabric linings and clothing, leaving them with a relentlessly monochrome and metallic character. While only the human body can truly distribute the weight of armour correctly, regimented displays extinguish much of its remaining vitality.

Pl.5, The entrance hall at Abbotsford, home of the historical novelist Sir Walter Scott, showing some of his collection of armour and weapons, c.1830 (whereabouts unknown, reproduced from Clive Wainright, *The Romantic Interior*, London 1989)

Traditionally, the study of arms and armour has also focused on the functional and the military. Writing on the relationship between armour and art has been restricted largely to specialist publications,[4] and unlike fashion history, the subject is still overwhelmingly male-oriented. It developed during a period in the nineteenth century when notions of masculinity were changing. Modern men had moved away from the flamboyant, peacock styles of the sixteenth century and presented themselves as sombre, restrained and hard-working. For men who studied armour, their focus was not on its shape, cut and style, but on its practicality: changes in shape reflected advancing weaponry more than the whims of fashion.

During the Victorian period the armed knight was both revered and ridiculed. Armour and weapons offered collectors an antidote to an urban, industrial age. This interest reflected a widespread love of all things Gothic. Novelists and painters created romantic visions of medieval chivalry and honour defended by knights in shining armour. At the magnificent tournament staged by the Earl of Eglinton in 1839, in a self-conscious revival of medieval pageantry, torrential rain caused a washout and, according to the *Annual Register*, 'the feudal appearance was sadly marred by thousands of umbrellas'.[5] The knight was becoming a figure of fun; indeed, most museum activities involving armour are to this day marketed largely at children.

Violence and Art

The combination of military outlook, partial survival and children's entertainment has detached armour and weapons from mainstream art history. While sculptural busts of men in armour and tapestries depicting great battles receive close attention, real armour and weapons are frequently ignored by art historians who dismiss their associations with violence, war and sport as anti-art, or reject them as 'boys' toys'.

This squeamishness can be pervasive. Common misperceptions regarding the terms 'medieval' and 'Renaissance' associate the former with words like 'dark', 'crude', 'violent' and 'disease'; the latter is characterized as 'light', 'sophisticated', 'romantic' and 'peaceful'.[6] Yet the Renaissance did not represent a clean break from the past: sophisticated designs for armour are medieval in origin, while violence continued as a legitimate means of settling disputes.

The separation of violence from art is new. It has been created partly by the present-day state monopoly on legal violence administered through the armed forces and the police, one of the mainstays of a modern civilized society. As authorized weapons became more tightly controlled they became more utilitarian, budget-restricted and standard-issue, ceasing to demand the attention of artists. This was not always the case. Before 1700, men at all levels of society carried knives, both as everyday tools and for self-defence. Weapons were often personalized and ornamented. It is perhaps an uncomfortable truth that even destructive weapons of war, whose main purpose was the taking of lives, might be decorated with exquisite artistry (see plate 6).

The martial arts were just one aspect of the whole range of learning that formed a Renaissance gentleman's education. Organized tournaments at which young aristocrats fought with swords, poleaxes and hammers taught the importance of nerve, self-control, ritual and ceremony. Hunting with spears, crossbows and guns tested strategy and bravery. Manuals of courtly behaviour advised on everything from dress and deportment to good manners and etiquette so that these skills could be employed appropriately. Violence was an aesthetic in itself.

Armour and Fashion

The huge growth in men's fashion in recent years is a reversal rather than an innovation. Twentieth-century concepts of masculinity descended from the Victorian period. Just as those concepts are challenged by men's clothes and hair products today, a slender calf in tight silk stockings was to Elizabethan onlookers a sign of virility. Renaissance men's clothes could be read as guides to status and outlook: the men who could afford rich fabrics and colourful armour were the fashion leaders of their day.

In this book, armour and weapons are moved away from the Victorian armoury and nearer to the Renaissance wardrobe. Armour, even for fighting, was fashion-dependent. Not only did armour and clothing develop in parallel, they were often worn in combination.

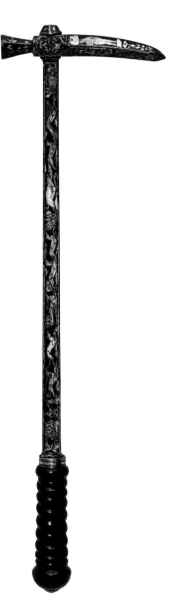

Pl.6, Horseman's hammer, c.1550, Germany, chiselled steel overlaid with silver and gold, nielloed, 50.8 x 15.3cm, V&A: M.538-1956

'Suits' of Armour

There is no such thing as a suit of armour. Contemporary inventories refer to 'an armour' or 'armours' when itemizing specific ensembles. As armour was a form of protective clothing, the modern term 'suit of armour', if taken literally, means 'a suit of suit'.

Armour was highly specialized and purpose-made. The best armour was made-to-measure, a unique and sometimes highly decorated representation in metal of a known individual. Armour literally embodies the wearer. When he died, a prince's armour became a sculptural memorial to his courage and honour.

Battle armour was relatively light and flexible. Even for heavy cavalry, whose initial charge with a lance might be followed by close infighting with swords, maces and hammers, agility and speed of movement during chaotic, noisy and dangerous combats were essential.

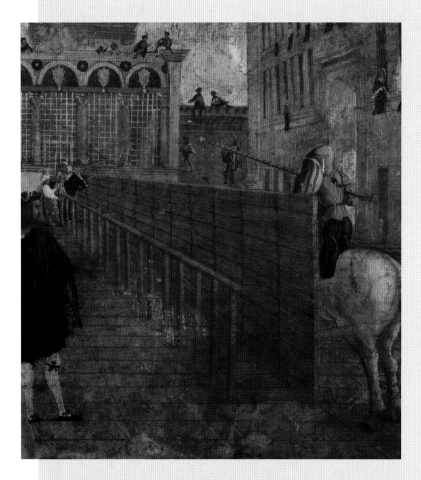

Pl.7, A Tournament at Brescia in the Piazza Maggiore (detail), c.1511, Floriano Ferramola, Italy, fresco transferred to canvas, 454.2 x 273.5cm, V&A: No. 8878-1861

Jousting and Tournament armour was much heavier and protected specific target areas of the head and body. Jousting was a dangerous sport and made up one of the final elements of a noble education. Separated by a barrier, opposing knights charged each other on horseback and aimed to break each other's lance or to unseat each other. Helmets had narrow eye-slits to reduce the risk of facial injury (see plate 7). Tournaments were less ritualized than jousts and prepared knights for war. Teams of cavalry opposed each other and clashed with blunted swords, hammers and maces until judges chose a winner.

Parade armour was showy and ostentatious. It was often intricately decorated and communicated majesty and authority during public celebrations such as coronations or the triumphal entry of princes into cities. Parade armour might be as much the product of the goldsmith as the armourer; it projected an image rather than protected a body (see plate 8).

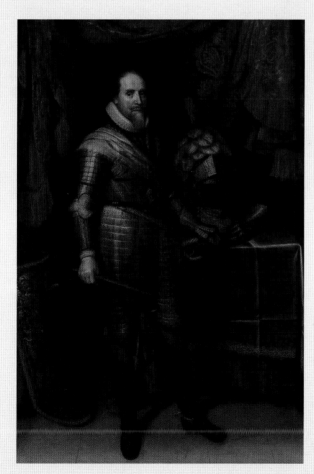

Pl.8, 'Prince Maurits, Stadhouder', 1615–20, Michiel Jansz. van Miereveld, Netherlands, oil on panel, 220 x 140cm, Rijksmuseum, Amsterdam

Armour and Weapons at the Victoria and Albert Museum

The European arms and armour at the Victoria and Albert Museum fit in with the spirit of princely patronage, adornment and social mobility. The collection comprises around a thousand objects dating from approximately 1250 to 1850. Its two areas of great strength are finely worked dress swords and firearms dating from around 1550 to 1800. The collection does not contain a full armour but has many parts illustrative of fashion, design and craftsmanship. It has been assembled primarily for its decorative qualities, although this should not imply that the objects were not designed to work.

Both clothing and armour also reflect wider artistic shifts. The same focus on height and lightness that created tall, elegant Gothic church spires produced an ideal body shape with a high waistline, slim hips and long, slender legs, accentuated further by pointed shoes and headwear. The bolder, more geometric and horizontal emphasis of the early Renaissance produced a burly, aggressive look designed to exaggerate the upper body. By 1600 the lower body was back in fashion, only this time the emphasis was on mass. The same voluminous hips and thighs created by the brushes of Rubens and Van Dyck were paralleled in the overblown leg-hose of the modern gentleman and the swollen leg armour of the cavalry officer.

Aspiring Envy
Swiftly changing fashions were a key feature of the Renaissance. By the end of the sixteenth century, new wealth had blurred class lines and made the luxuries enjoyed by the rich more widely available. Young men with aspirations challenged traditional notions of order with their modish dress and behaviour. They acquired the badges of wealth previously enjoyed by only a few, and wore pieces of armour and swords, daggers, pistols and gunpowder flasks, slung from equally lavishly decorated belts, effectively as working jewellery.

This was highly controversial. Throughout the period the way in which people presented themselves was regulated according to status by sumptuary laws. Those who transgressed risked fines, or at least mockery by conservative writers. As armour, clothing and jewellery became increasingly lavish and international in style, 'the stinkinge pride of apparel'[7] threatened the very fabric of society. One writer attacked the new breed of selfish gentleman when he outlined 'the abuses that Pride had bred in England, how it had infected the Court with aspiring Envy, the Citie with griping Covetousnesse, and the Countrey with contempt and disdaine: How since men placed their delights in proud lookes and brave attire, Hospitality was left off, Neighbourhood was exiled, Conscience was scoft at, and Charitie lay frozen in the Streets.'[8] Nevertheless, military fashions outlived the seventeenth century and continue to be popular today.

From before 1630, very few fabric items survive. Most perished through age or were cut up and recycled as furniture covers and hangings. Even highly valued clothing before this date is extremely rare; almost nothing survives of the clothing worn at Elizabeth I's court in England.[9] Armour therefore provides important evidence for understanding the history of fashion. It not only survives but retains its shape.

'

Wearing

'I see that the fashion wears out more apparel than the man.'

Let your apparel then, be very well made, and fit for your body: for they that wear rich and costly garments, but so ill favouredly shaped, that a man would weene the measure had been taken by another, give us to judge … that either they have no regard or consideration how to please or displease, or else have no skill to judge of measure or grace, or what doth become them.
Giovanni Della Casa, *Galateo of Manners & Behaviours*[10]

Fashion was a man's game. What's more, it was a young, rich man's game. Giovanni Della Casa's manual of behaviour for young gentlemen, published in Venice in 1558, encouraged youthful courtiers to embrace fashion only if it was tightly laced with appropriateness. Translated into Spanish, French and English and published repeatedly over the following 150 years, the no-nonsense manual advised on everything from suitable fabrics and right and proper tailoring, to polite speech, graceful walking, and how at all costs to avoid sweating in public. Above all, the *Galateo* preached conformity. 'Singularity, beyond all other ill customs, makes us generally spited of all men'.[11]

These young, rich men wore fashionable armour. They cut a dash. They were, according to Shakespeare, 'All furnish'd, all in arms; All plumed like estridges that with the wind; Baited like eagles having lately bathed; Glittering in golden coats, like images; As full of spirit as the month of May, And gorgeous as the sun at midsummer; Wanton as youthful goats, wild as young bulls.'[12]

The best armour was a serious investment. A 'garniture' might include

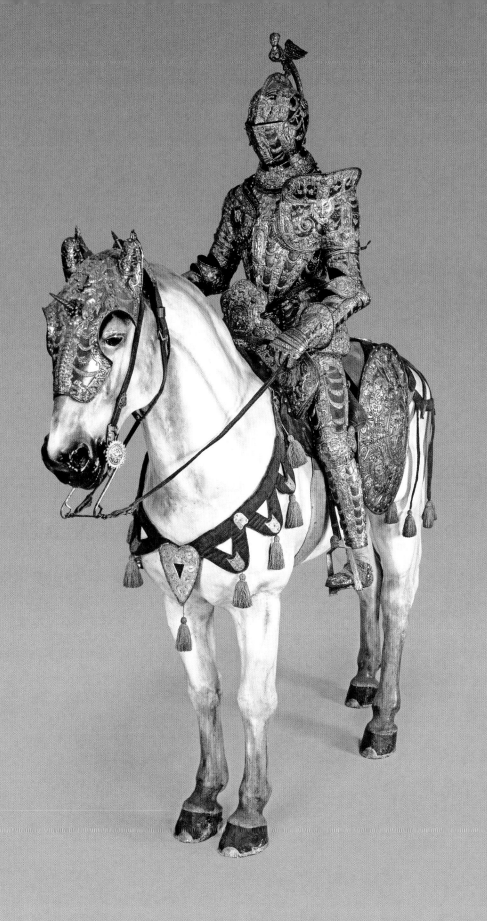

exchange pieces to allow an armour to be multi-purpose: an alternative helmet and reinforced breastplate for jousting, perhaps. These garnitures could be enormous and were decorated to match each other. In 1547, the Austrian Archduke Ferdinand II paid the armourer Jorg Seusenhofer 1,258 florins for his Eagle Garniture, still in the Imperial Armouries in Vienna, which contained 87 pieces.[13] He spent a further 463 florins on its gilding, a total cost in today's money of around two million pounds.[14] Twenty years earlier, Seusenhofer's father, Hans, had charged only 70 florins for a less elaborate armour.

Personal Image

No armour that expensive was going to be made without close consideration of style and image. During the early sixteenth century, high relief embossing and rich gold overlays began to decorate parade armour 'alla romana antica' (in the ancient Roman style), particularly in Italy. It was not just the architecture, literature and sculpture of the time that recalled glorious ancient traditions. Roman-style armour transformed Renaissance nobles into classical heroes.

Later parade armour was less self-consciously revivalist, although classical references continued as a source of inspiration. Parade armours reached their full flowering in the 1580s, their all-encompassing mannerist ornament the products of the most celebrated artists and goldsmiths (see plate 9). Lucio Marliani (also known as Piccinino), who decorated armour for Alessandro Farnese, Duke of Parma, was famous across Europe during his lifetime. He had, claimed Paolo Morigia in *The Nobility of Milan* (1595), 'in his ornamentation of iron in relief with figures, animals and grotesque masks, etc., and likewise in his damascened work, produced masterpieces which are among the most choice and precious'.[15]

Della Casa's *Galateo of Manners* had been published at the request of Galeazzo Florimonte, Bishop of Sessa, and firmly linked image, fashion and manners to morality. The man who spent beyond his means on his appearance was guilty of the sin of pride. It was one of many books commenting on male decorum. For the English Puritan Phillip Stubbes, who published his *Anatomie of Abuses* in 1583, pride was 'not only evil and damnable in its own nature, but also the very efficient cause of all evills'.[16] Underpinning this distrust of modern fashions was the fear that 'monstrous apparell', puffed, padded and billowing, distorted the figure unnaturally and hid God's work. Pride, claimed Stubbes, was 'tripartite;

namely the pryde of the hart, the pride of the mouth, and the pride of the appar-
ell which (unless I be deceived) offendeth God more than the other two.' Stubbes
looked back unrealistically to a time when costume followed the contours of the
body, was made from locally produced fabrics, and was unassuming.

Descriptions in household inventories reinforce the importance of personal
image. While paintings, furniture and kitchenware are listed briefly, the 'wearing
apparel' in rich and often imported fabrics decorated with gold and silver is
described at length and valued highly. A 1561 inventory at Wilton House of 'all
the gold and sylver plate, jewelles and apparell and warderobe stuffe with the
furniture of the stable, armorie and all other implementes of householde belong-
ing to the right honorable William, Earle of Pe[m]broke' lists pages and pages of
doublets, jerkins and hose in extraordinary detail: 'Item a jerkin of black satten
garded with velvett and the garde edged with satten passed throughe with lace
of black silke, lyned with taffata sarcenett, sett with ii dozen ii buttones snaile
fashion, white enameled'.[17]

Armour was more easily identifiable and less easily adaptable if stolen and
so did not attract quite such a level of detail, but its importance should not be
underestimated. One of Pembroke's armours made in the royal workshops in
Greenwich, under the master Erasmus Kirkener, is described: 'Item my Lord's
field armour of Erasmus making parcel gilt with the furniture'. Another was 'an
armour for my Lorde Herbert enameled and parcel gilt with his furniture.'[18]

Made-to-Measure

Like the best clothing, good armour was made-to-measure. Henry VIII had him-
self measured in person for his armour and arranged for his armourer to consult
his tailor. His surviving armours are testimony to his expanding girth as his waist
grew from thirty-eight inches to fifty-four later in life.[19] Noblemen without direct
access to a workshop sent items of clothing away to armourers so their armour
could be made to match.[20] The Spanish writer Luis Zapata was openly modish in
his advice to jousters during the 1580s: 'Like a cape or a smock', armour could
soon become old-fashioned, so new armour, lined snugly with silk and decorated
with gilding, was best. It was 'most unseemly for a jouster to move about in
armour rattling like kettles'.[21] Leg protection in particular needed to fit comfort-
ably for freedom of movement (see plate 10). Greaves, covering shins and calf

Pl.10, Greaves and Cuisse, *c*.1540, Augsburg, embossed steel, V&A: M.564&A-1927. From the Radizwill Armoury, formerly in the castle of Nieswiez, Poland.

muscles, and cuisses, covering the thighs, were unique to individuals and would require personalized alteration if they passed into different ownership.

While little evidence survives about the process of commissioning armour and the practices in the work-shops, a few surviving armourers' pattern books highlight the strong visual links with tailoring. An album produced in the royal workshop at Greenwich in around *c.* 1587 contains thirty designs for decorated armour, each annotated with the name of its owner. Alterations to some of the pages suggest the patterns were part of the design process rather than merely a record of completed work. Several of the armours survive (see plates 11 and 12).

Similarly, the Mantuan artist Filippo Orsoni produced designs for battle and pageant armour, to be made in a variety of materials, from steel to papier-mâché, according to need. Some of his designs are fanciful, but the component parts strongly outlined on the page and in his annotations point towards a basic instruction book (see plate 13).

Stylistic links between armour and clothing worked both ways. Apprentice tailors in Germany had to consult masterpiece books prescribing test pieces for their examinations. These were arranged by social level and included tournament dress for man and horse to be worn over armour.[22] It is no coincidence that Italian and German tailors' pattern books dominated the European clothing market during the early sixteenth century, when Italian and German armour was also the most prestigious. The marketing of off-the-shelf and second-hand armour was also part of the clothing trade: in Florence one could buy breastplates, helmets, swords and spurs from drapers' shops, particularly convenient if the armour needed padding to fit.[23]

Like men, horses were unique and their trappings and armour equally personalized. The Spanish tailor Juan de Alcega described in his *Book of the Practice of Tailoring* (1579) the process for designing silk trappings for jousting: 'A pattern

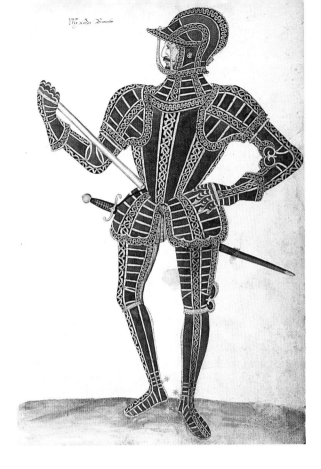

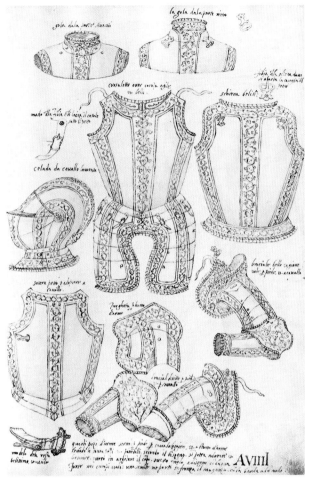

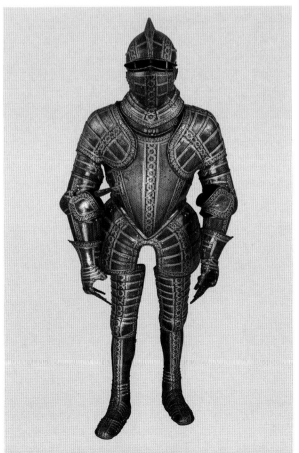

ABOVE, LEFT
Pl.11, 'My Lord Bucarte', from the *Almain Armourer's Album*, *c*.1587, Jacob Halder, Greenwich, England, pen, ink and watercolour on paper, 43 x 29.2cm, V&A: D.613-1894. Design for armour for Thomas Sackville, Lord Buckhurst.

LEFT
Pl.12, Armour of Thomas Sackville, Lord Buckhurst (as illustrated in the design above), *c*.1587, Royal Workshop, Greenwich, England, steel, leather, gold and copper alloy, Wt 32.03kg, Wallace Collection, A62

ABOVE
Pl.13, Armour components from an album of designs dated 1554, Filippo Orsoni, Mantua, Italy, pen, ink and wash, 41.9 x 28cm, V&A: E.1764-1929

of canvas must be made first, fitted on the horse and the trappings cut after the pattern in order to ensure that they fit the horse perfectly.'[24] Horse and man fought, jousted and paraded as one and their armour was made to match. Horse armour incorporated the civilian dress styles that influenced body armour to create a unified whole (see plate 14).

The transformation of armour from the lightweight and initially plain, figure-hugging outfits of the fifteenth century, to the grandiose and overstated forms of the early sixteenth century, and on to the colourful, extravagantly decorated ensembles of the 1580s, is only partly due to military history. On a functional level, the Renaissance emphasis on large numbers of organized and mobile infantry, a conscious revival of ancient Roman strategies, encouraged the proliferation of half armours, in which the legs and arms were protected only by cloth or leather rather than by metal. Machiavelli's *The Art of War* (1521) preached the importance of discipline, training and geometric troop formations inkeeping with Roman armies that to some degree depersonalized warfare. In 1512 Henry VIII bought 2,000 light armours from Florence at 16 shillings each, which, for the sake of cost and efficiency, indicate standard items and a certain uniformity of appearance.[25]

The development of firearms has also long been credited with making armour heavier and more rounded to deflect lethal musket balls: the cavalry officer of the early seventeenth century had to choose between the extra protection of a full armour, or greater mobility with only a breastplate, backplate and helmet.

But the parallels in shape between armour, even of 'munition' quality, and clothing throughout this period, and their in-tandem changes, identify armour as costume, as prone to transformations in fashion as architecture, painting and sculpture. Indeed, military changes encouraged this. Whereas medieval princes fought side by side with their troops, the Renaissance nobleman acted increasingly as general, supervising strategy and playing the role of figurehead. Even his battle armour might be highly decorated with etching imitating embroidery, his shoulder draped with a bright silk scarf, his helmet adorned with dyed ostrich feathers.

Fashion and the Law
Fashion was fickle. 'The garments of the olde world, have lost their date, for men of this age and this season to weare,' wrote Della Casa.[26] The Spanish tailor Juan

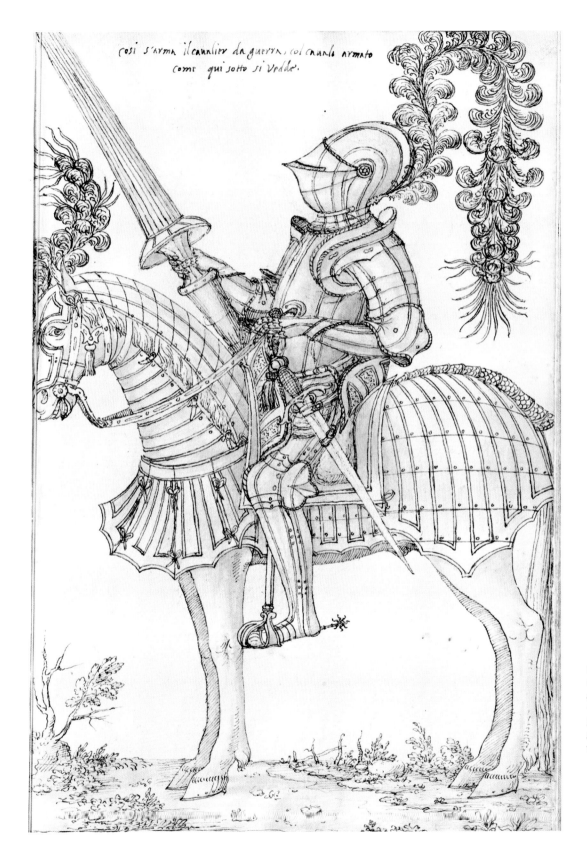

cosi s'arma il cauallier da guerra, col cauale armato
come qui sotto si vedde.

Pl.14, Battle armour for
man and horse from an
album of designs dated
1554, Filippo Orsoni,
Mantua, Italy, pen, ink
and wash, 41.9 x 28cm,
V&A: E.1725-2031-1929

de Alcega complained, probably only half-heartedly, 'As men are naturally so different in character and opinion and differ so widely in their customs and are so rash in their judgement, there is nothing on earth that is so perfect or so masterly that it will satisfy all of them.'[27] The English vicar William Harrison was less sanguine in his *Description of England*: 'And as these fashions are diverse, so likewise it is a world to see the costliness and the curiosity, the excess and the vanity, the pomp and the bravery, the change and the variety, and finally the fickleness and the folly that is in all degrees, insomuch that nothing is more constant in England than inconsistency of attire … Oh how much cost is bestowed nowadays on our bodies and how little upon our souls.'[28]

Yet fashion was no free-for-all. It was restricted by cost and by law. Sumptuary legislation sought to protect the status quo by limiting choice according to rank. It attempted to provide clarity by linking in law appearance with social status. Della Casa summed up the thinking: 'Thou must in any case respect thy condition or estate. For, A man of the Clergie, must not be attired like a Souldier: nor a Souldier goe like a Player.'[29] English proclamations, for example, permitted only knights or men with more than £200 of property or an annual income of £20 or more to wear silk, satin and sable, or to decorate their clothing with gold and silver thread.[30]

In 1565, a servant, Richard Walweyn, was arrested in London for wearing 'a very monstrous and outrageous great pair of hose',[31] but there is little evidence that sumptuary laws were systematically enforced in court. This has led historians to dismiss them as not particularly relevant. However, constables and watchmen were empowered to enforce the law themselves, a much cheaper solution. Sumptuary law proclamations were social barometers for their time. In linking clothing to monetary value they were an acknowledgement that people felt pressure, socially and financially, to conform to changing fashions. Recent research into surviving inventories of clothing suggest people largely conformed until the later period.[32]

While the legislation did not take aim at armour specifically, it did restrict the cuts and shapes of garments, hats and shoes mirrored in armour. It also targeted the clothes worn with armour. The laws were overwhelmingly targeted at young men. In *Much Ado About Nothing* Shakespeare described fashion as a 'deformed thief' that 'giddily a' turns about all the hot bloods between fourteen and

and five-and-thirty'.[33] In Italy, and in particular Florence, both men's and women's attire and behaviour were the targets.

Sumptuary proclamations were medieval in spirit: they promoted stability in societies whose harmony was based to a large degree on deference. They were most frequently issued during the early Renaissance, when the pace of change picked up, new wealth created new demands, and the social order was challenged.[34] As such they represented a rearguard action by local authorities in response to change. Early edicts targeted largely those of gentry status and above, but not the highest levels of aristocracy. They had a moral dimension regulating behaviour as well as dress. Mid-fifteenth-century Nuremberg laws restricted not only what could be worn at weddings but also how much was to be spent on festivities and gifts. Later laws were more widely targeted and policed the behaviour of servants and apprentices.[35]

In particular, legislation targeted excessive spending on imported luxuries that were becoming more widely available throughout Europe. 'Unnecessary foreign wares' such as 'superfluities of silks, cloths of gold, silver, and other most vain devices' were deemed, in an English law of 15 June 1574, to be ruining 'a great number of young gentlemen, otherwise serviceable, and others seeking by show of apparel to be esteemed as gentlemen, who, allured by the vain show of those things, do not only consume themselves, their goods, and lands which their parents left unto them, but also run into such debts and shifts as they cannot live out of danger of laws without attempting unlawful acts.'[36]

Armour and Clothing 1480–1620

The interaction between armour and fashion is close and complex. The medieval knight was clothed under his armour so the two needed to be tailored to fit comfortably. Over the armour might also be further fabrics. From the mid-fifteenth century it was less common for armour to be concealed, and decorating its surface in the same way as fabrics became the norm.

Armour and clothing styles did not simply sit side by side, occasionally influencing each other; the lines between both are frequently indistinguishable. Lorenzo de' Medici's posthumous inventory of 1492 itemized odd bits of armour, including his own leg defences worn in town as decoration rather than defence.[37] Protective 'base coats' were of leather or textiles decorated with gold and silver

thread and riveted with metal plates. Brigandines were fabric-covered doublets lined with overlapping metal plates that were both fashionable and protective. The Earl of Pembroke's inventory contains 'Item an arminge doublett of Millian [Milan] fustian white with buttons of white silke.'[38] An Elizabethan proclamation of 1579 expressed outrage at any who 'presume audaciously to apparel themselves' in any 'secret kind of Coat and Doublets of defence … thereby intending to quarrel and make affrays upon other[s] unarmed'.[39]

Coats of mail might also be worn under civilian shirts about town or while travelling. The hot-headed Florentine sculptor, goldsmith and soldier Benvenuto Cellini rarely ventured far without his mail as personal vendettas against him mounted. After causing a fight near Siena, he interrupted what he thought were his apprentice Pagolo's dying gasps by berating him for not dressing for protection when on the road. 'So coats of mail are worn in Rome to please the ladies, but when there's a danger and they have a purpose to serve they're packed away? You deserve all you've got.'[40]

Today we are so used to slipping on one-piece jumpers and jackets that it takes a leap of imagination to see how the construction of armour and clothing compare. During the sixteenth century, a man's doublet might have detachable sleeves, a forerunner of the waistcoat, making comparisons with breastplates and backplates more obvious. Similarly, a woman's bodice was referred to as a 'pair of bodies', as, like body armour, it consisted of a front and a back joined at the sides.[41] Whether one dressed in iron or in cloth one did so piece by piece.

The knight, officer and soldier of 1630 faced different threats on the battlefield from their predecessors 200 years earlier, but their appearance is very much that of the prevailing fashion.

1480–1500

During the late fifteenth century, armour was at its most elegant. Closely fitting the profile and contours of the body, armours emphasized a high waistline, narrow hips and long legs. The stress was on vertical lines, accentuated by long, pointed sabatons (foot defences) and long-tailed helmets. Contemporary clothing emphasized similar attributes.

The centrepiece of any armour is its breastplate. One of the most common items of clothing during this period was a doublet open at the sides (see plate 15).

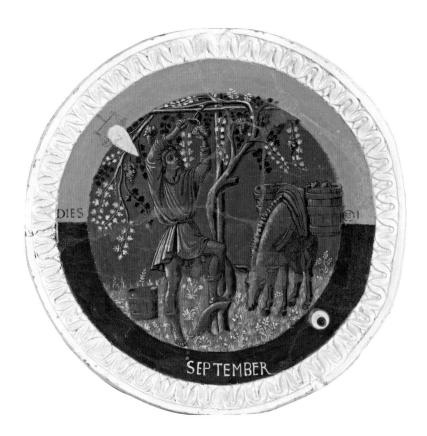

Pl.15, 'September' roundel from *The Labours of the Months*, *c.*1450–56, Luca della Robbia, Florence, Italy, tin-glazed terracotta, diam. 60.3cm, V&A: 7640-1861

This descended from a simple piece of cloth, with a hole for the head, that hung loosely back and front. Tying this with a belt around the waist immediately gave the doublet its shape. Naturally, below the belt was created a small skirt which, in Italy, could hang down to the mid-thigh. Above and below the belt the gathered fabric created pleats and folds. To have a doublet with deep pleats and folds required more fabric, a privilege of the wealthy under sumptuary legislation.

Late fifteenth-century body armour follows these conventions exactly (see plates 16 and 17). Hans Talhoffer's treatise *Fechtbuch* (Fightbook), on the art of combat, illustrates a knight about to settle a dispute with his sword, in which the embossed decoration of his breastplate radiates outwards from the waistline in fluted lines in imitation of the folds of a doublet. Later these flutes were hammered more vertically in parallel with the more rigid pleats created by padding the doublet.

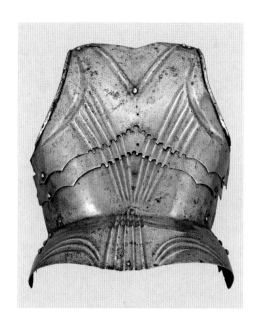

Talhoffer's illustration also shows on both the combatant and his attendant the short skirt popular in western Europe from the mid-fifteenth century. Leg armours, like stockings, were not worn as trousers but as two separate garments, the gap between them covered by a gusset of mail for armour or leather for clothing. By 1500 this gusset had transformed from an item of modesty into a protruding codpiece celebrating the male genitalia. This was a sexually aggressive outrage for ageing lawmakers who still wore the long gown. 'No person under the estate of lord, including knights esquires and gentlemen, to wear any gown, jacket or cloak which does not cover the genitals or buttocks' proclaimed an English law of 1463, exempting, perhaps, the very top ranks from sexual boasting.[42]

Pl.16, Backplate, *c.*1480,
Germany, steel, fluted,
Wt. 2.13kg,
Wallace Collection, A208

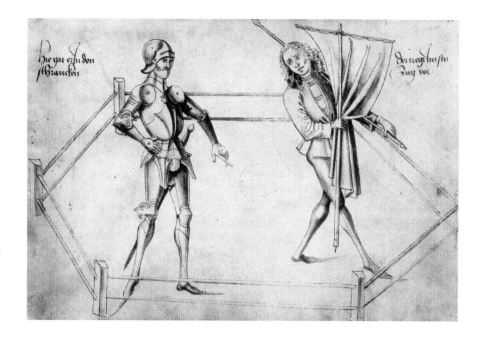

Pl.17, 'Armoured Combat in the Lists with Spear and Sword', *Fechtbuch*, 1467 edition, Hans Talhoffer, Germany, British Library, 7905.i.2

Long, pointed shoes, like those worn by Talhoffer's attendant, were also attacked as distorting God's work. Nuremberg Council received a letter from the Bishop of Bamberg in 1453 ordering cobblers 'to make no more peaks on shoes',[43] while in Bern shoemakers were warned in 1464 not to make shoes with points longer than 'one finger'.[44] Long, 'piked' sabatons are one of the distinctive characteristics of late-fifteenth-century armour and attacks on them were targeted, therefore, at contemporary fashions among young men.

The long-tailed helmet is also a feature of late-fifteenth-century armour. It has long been interpreted as neck protection against sword blows, and it may well have provided this, although this does not explain its role in jousting. The tailed helmet coincided with the fashion for shoulder-length hair, both of which emphasized the elongated forms popular in late Gothic design. Both also disappeared around 1500 when shorter hair and a more rounded profile took hold, although the threat of being attacked with a sword did not disappear with them.

1500–1550

Armour styles underwent an extraordinary change in the first decades of the sixteenth century. Gone was sinuous, willowy grace, as burly, overblown armours proclaiming a powerful upper body took over. Pinched waistlines, broad hips, square shoulders and straight necklines characterized armour in parallel with both men's and women's clothing. Many doublets remained pleated, but the pleats were narrower and ran closer to parallel to each other than the radiating Gothic pleats as doublets were more often padded.

Stockings became two separate garments, upper stocks and lower stocks, the former similar to knee-length shorts today, but tied at the bottoms. A pleated skirt might also be worn, often richly decorated, that was imitated in armour and called a tonnelet, used in organized foot combat where it allowed freedom of movement, and on horseback when it needed an opening at the front.

'Fluted' armour in imitation of this style, with a corrugated surface of close vertical ridges, was highly popular in Germany (see plate 18). Its popularity coincided with the later reign of the Emperor Maximilian I (1459–1519), whose armourers at Innsbruck were admired across Europe. The ridged surface has traditionally been credited with strengthening the armour against slashing sword blows, but this appearance is more likely a fashion statement, for both man and

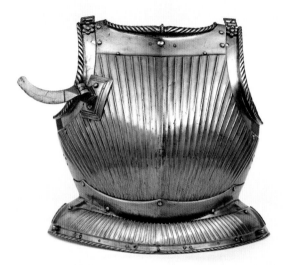

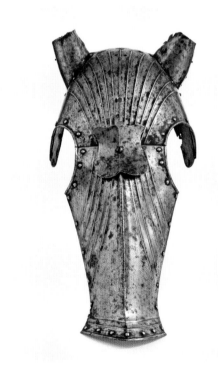

horse (see plates 19 and 20). The pleats are still pinched at the waist, and all such armour is plain below the knee in imitation of stockings, even for cavalry whose legs were vulnerable. This style disappears around 1540 when more restrained Spanish fashions started to dominate in Europe and make their presence felt on armour.

The change from upwards to outwards was expressed most eloquently with shoes. The long, pointed 'pikes' and 'poulaines' of the fifteenth century gave way to an equally impractical square-toed shoe that might be almost as wide as it was long (see plates 21 and 22). This fashion was long-lived. In England under Mary Tudor, a sumptuary edict stated that: 'No man should wear his shoes above 6 inches square at the toe.'[45] The immediate application of this style to armoured 'sabatons', often referred to today as 'bear-paw' sabatons, is an indication of how fashion-conscious were the armourer's customers.

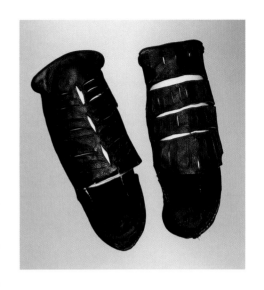

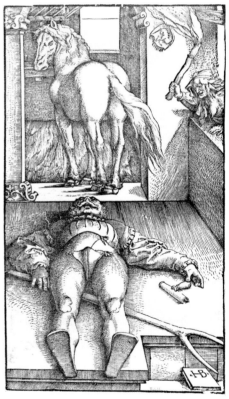

OPPOSITE, FAR LEFT
Pl.18, Fluted armour,
*c.*1515–25, Germany,
steel, Wt: 18.99kg, The
Wallace Collection, A24

OPPOSITE, ABOVE LEFT
Pl.19, Fluted breastplate
for tournament armour,
1530–40, Wolf
Grosschedel, Landshut,
Germany, steel, V&A:
M.197-1951

OPPOSITE, BELOW LEFT
Pl.20, Fluted shaffron
(face-guard for a horse),
1520–30, Germany,
embossed steel,
H: 60cm,
V&A: M.2711-1931

RIGHT, ABOVE
Pl.21, Two shoes,
1520–40, probably
London, England,
tanned leather,
22.5 x 9cm and
23 x 8cm, V&A: T.412-
1913 and T.413-1913

RIGHT
Pl.22, 'The Bewitched
Groom', 1544–5, Hans
Baldung, Strasbourg,
France, woodcut, ink
on paper, 34 x 20.2cm,
V&A: E.1777-1938

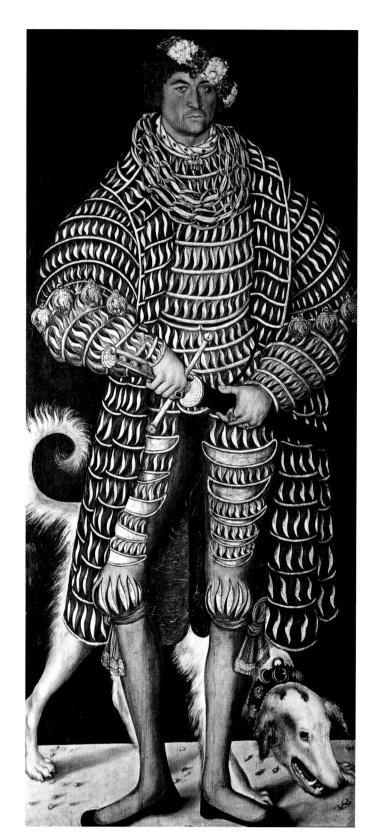

Pl.23, 'Henry the Pious,
Duke of Saxony', 1514,
Lucas Cranach the Elder,
Germany, oil on canvas
transferred from wood,
184 x 82.5cm, Gemälde-
galerie, Dresden

This was also the era of puffed, slashed and layered clothing (see plate 23). Sleeves were drawn into huge, billowing folds, revealing expensive interlinings in contrasting colours, while linen shirts were pulled through slits in the fabric of the doublet (pinking). The effect could be outrageous. 'For his breeches', wrote the French satirist François Rabelais in *The Life of Gargantua and Pantagruel*, 'were cut in the form of pillars, chamfered, channelled and pinked behind, that they might not overheat his reins: and were, within the panes, puffed out with the lining of as much blue damask as was needful … For his codpiece … was fashioned on top like unto a triumphant arch, … jagged and pinked and withal bagging and strutting out with the blew damask lining, after the maner of his breeches.'[46] For the poet Alexander Barclay this was no laughing matter. He railed at those who 'are not content as God hath you made, his work is despised, You think you more crafty than God omnipotent, Unstable is your mind, that shows by your garment.'[47]

Baldassare Castiglione scoffed in *The Courtier* of 1528 that too much fancy clothing made a man look like a jester and consequently 'he will be taken lightly', but one did so at one's peril as this was a fashion championed by notoriously violent Swiss and German mercenary soldiers (see plate 24). Much is made of the

Pl.24, 'Five German Soldiers', print taken in 1910 from an etched plate also in the V&A's collection of *c*.1520, plate by Daniel Hopfer of Augsburg, etching; ink on paper, 20.6 x 38.1cm, V&A: M.6292A-1910

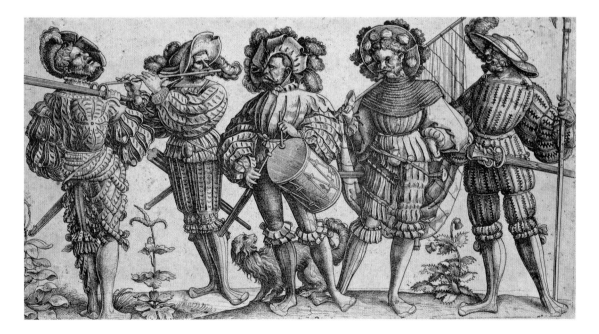

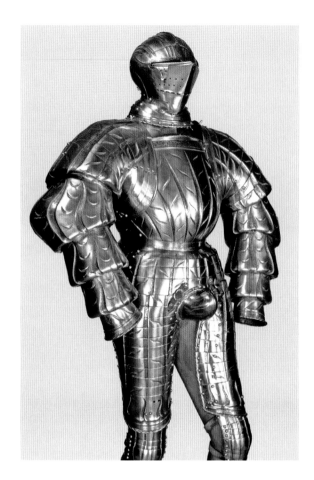

influence of printing on spreading fashion, but the role of these 'Landsknecht' warriors should not be underestimated. They served in most European armies (and often fought against each other); in 1545, Henry VIII raised 2,800 German horse and 10,400 Landsknechts to serve in France.[48]

The Landsknechts were credited, even in contemporary accounts, with inventing the fashion for slashing clothes after apparently tearing strips from the banners and tents of the vanquished at the Battle of Grandson in 1476 to patch up their tattered garments, but this fashion was older than that.[49] A law in 1404 condemned strips and cutouts for their wastefulness, and even Chaucer described slashed clothing as 'a wast of cloth in vanitee'.[50] But the Landsknechts took this fashion to its limit. The slashes in their clothing are often referred to as dagges, a term also used for sharp blades, suggesting they may be symbolic of war wounds, trophies of bravery.[51] The style spread far and wide and lasted well into the seventeenth century. England, an absorber of German fashion, was not immune. The Pembroke inventory contains, among many examples, 'Item a doublett of grene satten pinked with small cuttes laied aboute with chaine lace of crimsen, silke and golde.'[52]

Nowhere can this fashion be seen better in three dimensions than in a parade armour made in Augsburg in around 1525 for the military commander Wilhelm von Roggendorf (see plate 25). The billowing sleeves, breastplate and leg harness have imitation slashed vertical panes with diagonal cuts worked into the surface. The broad shoulders and inflated breastplate are a symbol of masculine virility, underscored of course by the magnificent codpiece. The long tassets covering the thighs mimic slashed trunk-hose tied at the knee, and indeed would have covered just such a pair.

These northern European fashions were not entirely matched in Italy, where the climate perhaps discouraged the excessive layering of clothing. In fact, for pageant and parade, figure-hugging styles became more pronounced as closer proximity to archaeological remains enabled a whole-hearted embracing of classicism. This armour *all'antica* included the muscled cuirass (body armour) as a common feature, and along with fantastical helmets was a speciality of the best known of all armourers, the Negroli of Milan. The earliest complete armour in this style to survive was made in 1546 by the Mantuan goldsmith Bartolommeo Campi and is in the Royal Armoury in Madrid (see plate 26), but evidence of this style becoming popular comes much earlier (see plate 27).

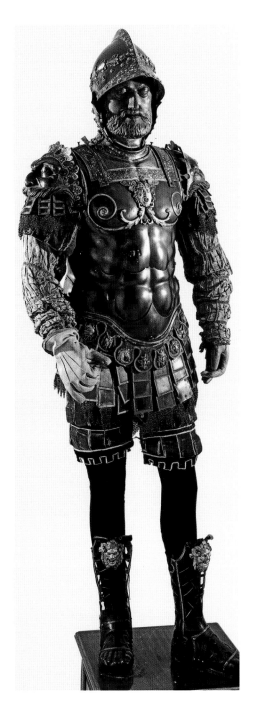

FAR RIGHT
Pl.26, Classical armour of Duke Guidobaldo della Rovere, Duke of Urbino, 1546, Bartolommeo Campi, Pesaro, Italy, steel, gold, silver and brass, Real Armeria, Madrid: A 188

RIGHT
Pl.27, 'The Shouting Horseman' (detail), *c.*1510–15, Andrea Briosco, Padua, Italy, bronze, H: 33cm, V&A: A.88-1910

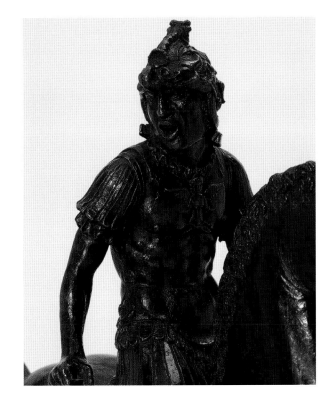

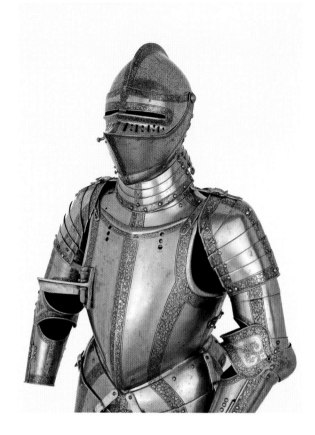

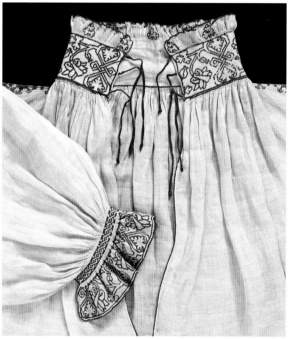

1550–1570

The rise to power in the 1530s of the Spanish Habsburg family ushered in a new era that combined a more restrained form with opulent decoration. Doublets, jerkins and breastplates became less globose, creating a narrower silhouette for the upper body. Decoration was contained within the body shape in the form of bands of etched ornament on armour and embroidery on clothing (see plates 28 and 29). The fashion extended once more to horses (see plate 30). Keeping horses was expensive and they were in themselves an accessory of the rich; a horse in complete body armour and trappings made a magnificent spectacle.

Shirts were buttoned closed at the neck, with a high collar and sleeves frilled at the wrist that protruded from under the doublet, the first shoots that later flowered into magnificent linen ruffs and cuffs. Doublet sleeves still billowed at the shoulders but tapered to the wrists.

The narrower, more vertical profile for the upper body was accentuated by a more defined central line of buttons down the doublet and matched by a strong medial ridge on the breastplate (see plate 31). Breastplates with bands of gilding imitated luxurious Spanish velvet doublets with fringes of gold thread (see plates 32 and 33).

Clothing was less flexible as it needed to be tailored to the silhouette, making it less adaptable when the fashion or ownership changed. 'It is such an ill shapen sight, to see a

OPPOSITE, TOP LEFT
Pl.28, Etched armour,
*c.*1550–60, Wolfgang
Grosschedel, Augsburg
and Landshut, Germany,
etched steel, Glasgow
Museums: 3436

OPPOSITE, BELOW
Pl.29, Boy's shirt (detail),
*c.*1540, England, linen
embroidered with silk
thread, V&A: T.112-1972

RIGHT
Pl.30, Etched shaffron,
*c.*1550, Augsburg,
Germany, embossed
steel with etched and
gilt decoration,
52.5 x 24 x 10cm,
V&A: 616-1893

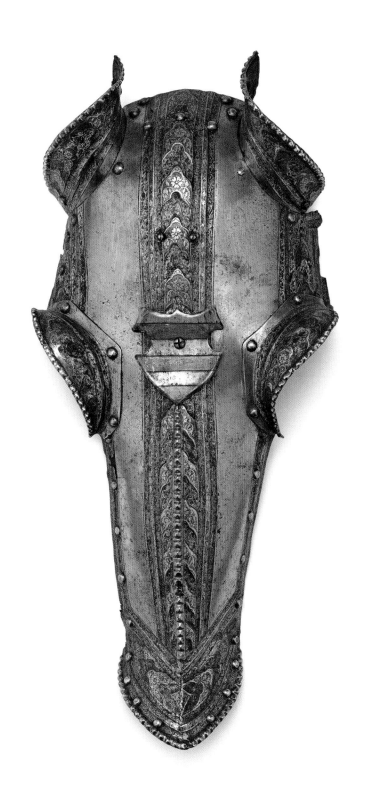

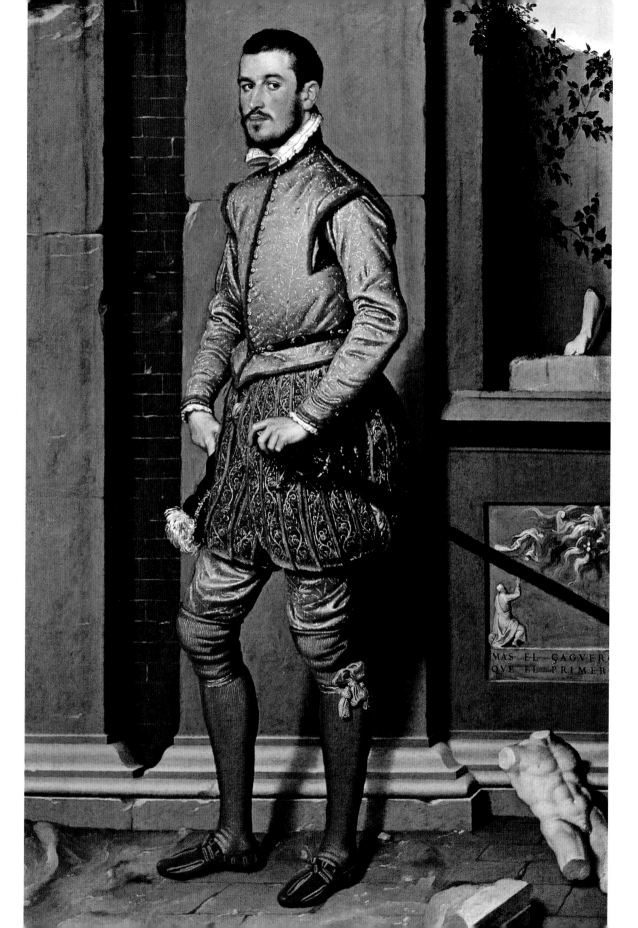

man clad with other mens clothes: that a man would ween there would be a fray between the doublet and the hose: their clothes do sit upon them so untowardly,' complained Della Casa in his *Galateo of Manners*.[53]

The long trunk hose retreated up the legs, were padded more than before and were sometimes paned in strips. They were now turned up at the bottom and tied above the knee, adding to their exaggerated roundness. This gave the lower body a new presence, but whereas sixty years earlier the legs were celebrated for their slenderness, now mass and bulk were idealized. The impression was exaggerated further by the more figure-hugging doublet.

Combinations of armour and clothing encouraged military fashions about town. Della Casa was not keen, suggesting they were the products of aggressive communities:

These same feathers, which the Neapolitanes and Spaniardes be wont to weare, and braveries and Embroderies: have but ill place amongst grave gowned men, & the attires that Citizens doe weare. But their Armour and weapons become suche place a greate deal worse. So that, looke what hapely might be allowed in Verona, would not, perchaunce, be suffered in Venice. For as muche as these gallants, all begarded, and huffing in fethers, & warlike fellowes, would not doe well, in this Noble Citie so peacefull & Civil. Suche kinde of people be rather, in maner, like nettles and burres, amongst good and sweete garden of Man flowers.[54]

1570–1590

Except for parades and tournaments, which demanded a more theatrical approach, full plate armour was worn less by the mid-century, and combinations of armour and clothing blurred the lines between soldier and civilian. Well-rewarded military

commanders, keen to show off their new
wealth, posed for portraits in rich velvets, fine
silks and starched ruffs, but retained elements
of armour to emphasize their profession (see
plate 34).

Early in this period, bulbous trunk hose
remained fashionable. To accommodate them,
armoured tassets for the upper thighs took on
a broad, inflated appearance, actually extend-
ing horizontally from the waist before turning
downwards (see plate 35). Later in the century,
the hose moved still further back up the thighs
to promote long, slender legs in an echo of the
fashion a hundred years earlier.

The most pronounced change, however,
was the exaggerated quilting and padding of
the doublet into a point hanging down below
the waistline and over the hose. This is re-
ferred to as 'peascod' shape, an old term for a
peapod, especially one still containing peas.
This impression of a full and swollen belly
is suggestive of the well-fed gentleman. It
moved Stubbes once again to ridicule: 'What
handsomeness can there be in these doublets
which stand on their bellies like, or much

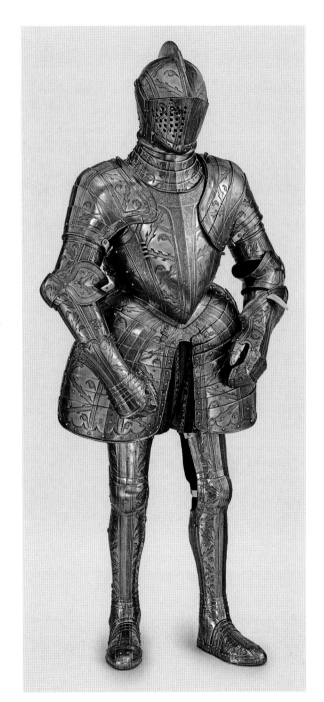

Pl.35, Field and tilt
armour of Robert Dudley,
Earl of Leicester, deco-
rated according to the
designs of Jacob Halder,
c.1575, Greenwich,
England, steel, Royal
Armouries, Leeds:
II.81, VI.49

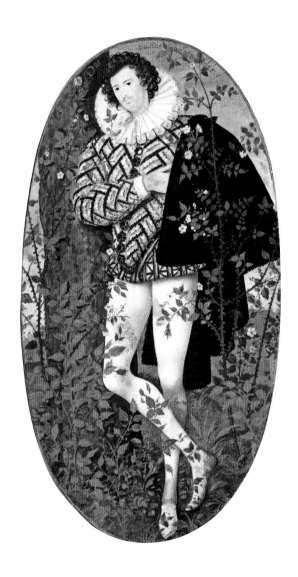

bigger than, a man's codpiece … for my part, handsomeness in them I see none and much less profit. And to be plain, I never saw any wear them but I am supposed him to be a man inclined to gourmandice, gluttonie and such like.' He claimed these doublets were 'stuffed with four, five or six puinds of bombast at least'.[55] A miniature by Nicholas Hilliard shows this fashion at its most extreme, the doublet extending well below the top of the hose (see plate 36).

Serving no obvious function, the 'peascod' breastplate was the military man's contribution to this fashion (see plate 37). This did not apply simply to high-style armour. Off-the-shelf components equipping militia men and foot soldiers also stretched and contracted according to fashion, although it is likely they remained in service for longer (see plate 38).[56] According to Luis Zapata, bulging breastplates boosted a jouster's confidence.[57]

Combinations of clothing and armour beg the question of whether they were designed to match. Were the hose intended to be worn only with a particular breastplate, or vice versa? One portrait from around 1590, of the Italian field marshal Lucio Foppa, shows his paned hose embroidered with geometric patterns replicated exactly in the gilded, etched bands of his peascod breastplate (see plate

ABOVE, LEFT
Pl.37, 'Peascod' breastplate, *c.*1585, probably Antwerp, etched steel, traditionally associated with Robert Dudley, 2nd Earl of Leicester, Middle Temple, London: 75002

ABOVE, RIGHT
Pl.38, Half armour for infantry, *c.*1580, steel, Middle Temple, London

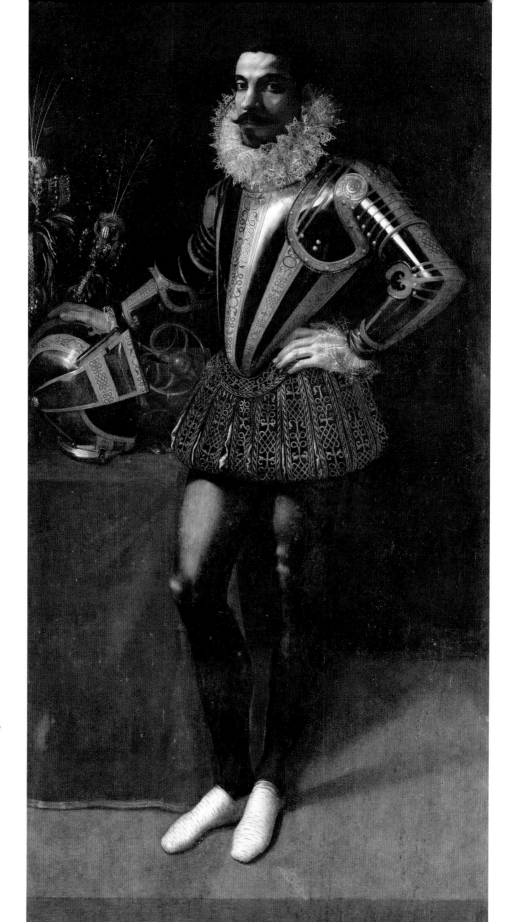

Pl.39, Lucio Foppa,
*c.*1590, Giovanni
Ambrogio Figino, Italy,
oil on panel,
105 x 50cm, Pinacoteca
di Brera, Milan. The
etched decoration on the
breastplate matches the
embroidered decoration
on the hose.

39). The armour, the hose, the stockings and the shoes are colour-coordinated throughout, while his head is framed by an elaborate ruff. This ensemble constitutes a complete outfit.

Few fabrics worn with sixteenth-century armour survive (see plate 40). 'Undressed' armour in museum displays can sometimes appear out of context, unable to communicate the grandeur and stateliness it once conveyed. There was a

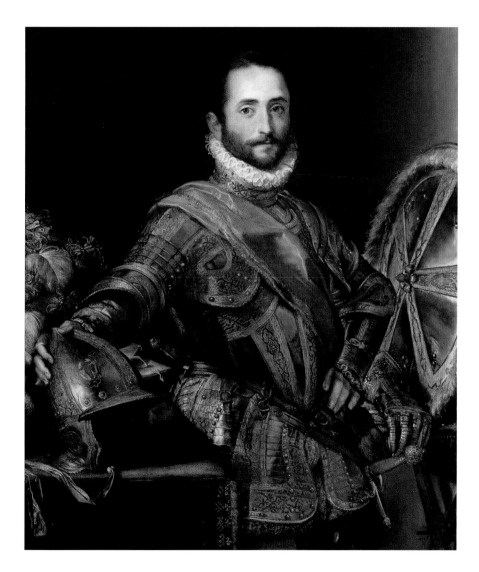

Pl.40, Francesco II della Rovere, 1572, Federico Fiori Barocci, Italy, oil on canvas, Galleria degli Uffizi, Florence

theatricality to armour and clothing of this period expressed in vivid and mean-
ingful colours. An Italian treatise on symbolism suggested that black, a common
colour under Habsburg dominance, was associated with grief, whereas white
signified faith and humility. Red was the colour of courage, green of love, and
yellow of hope.[58] Where fabrics do survive, much of their colour has faded from
exposure to light. An extremely rare survival is a military scarf which once
belonged to Sir Francis Drake and was reputedly presented to him by Elizabeth
I (see plate 41). Its green silk is as iridescent as the day it was made, while the
embroidered fringes are in immaculate condition. Along with the scarf is a silk

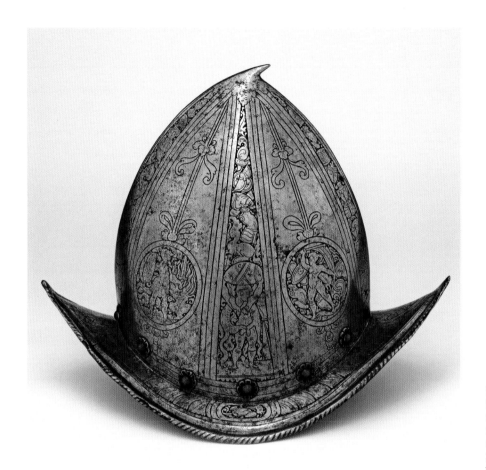

Pl.43, Infantry helmet
(morion), c.1580, etched
with the classical story
of the Labours of
Hercules, Italy, steel,
27.5 x 35.2 x 24cm,
V&A: M.2810-1931

cap with similar embroidery to the scarf (see plate 42). The cap is conical in shape, typical of the period, and compares with the 'morion' helmet worn by infantry and militia guards at the same time (see plate 43).

1590–1620

Armour is often portrayed as declining after 1600 as the increasing lethality of firearms called for heavier and more specialized protection. The image of the mid-seventeenth-century soldier in buff coat, breastplate and helmet is a familiar one, as soldiers wore armour whose weight would allow them to protect only their vital organs.

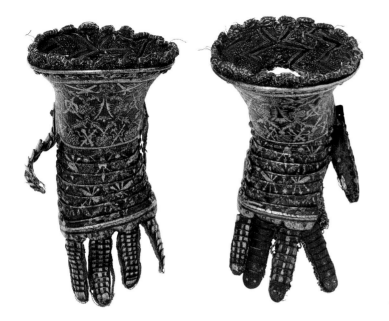

Pl.44, Pair of gauntlets, c.1614, Milan, Italy, damascened steel with crimson silk lining, 24.5 x 13 x 13.7cm, V&A: 1386&A-1888. From armour presented to the sons of Philip III of Spain.

However, the decline has as much to do with armour going out of fashion among the aristocracy. Impressive parade armours decorated by goldsmiths were still commissioned, though less frequently. A pair of gauntlets inlaid with silver and gold and still with their original lining of silk embroidered with gold thread, from a garniture made for the future Philip IV of Spain, is a good late example (see plate 44). Yet portraits of the period, when sitters wanted to look their best, were more frequently painstaking depictions of expensive clothing in international styles than heroic visions in armour.

The heavy armour that was produced was still fashion-dependent. The rising waistline of civilian dress was matched in armour, an area where one might expect mobility to be sacrosanct (see plate 45). The bulging torso became pinched and gave way to inflated thighs, representative of the ideal body shape. The cut of hose was deliberately rounded at the sides, a feature replicated in the huge tassets that protected the thighs. The breastplate and doublet both became square with a more pronounced skirt below the waistline (see plates 46 and 47). A dress alternative to the starched ruff was the falling lace band that gave the collar a more restrained, shallow-cone profile, a detail picked up on the neck guards of cavalry helmets.

Some armour even adopted the naturalistic embroidery popular on early-seventeenth-century fabrics. The vines, roses, snails and dragonflies etched on a Flemish cavalry helmet drew on a repertoire of ornament that also decorated bed hangings, gowns, sleeves, gloves and hats (see plates 48 and 49). This was a period of growing botanical interest encouraged by printed publications such as John Gerard's *Herbal or General History of Plants* (1597) and repeated translations of Andrea Alciato's *Emblemata*, first published in Augsburg in 1531.[59]

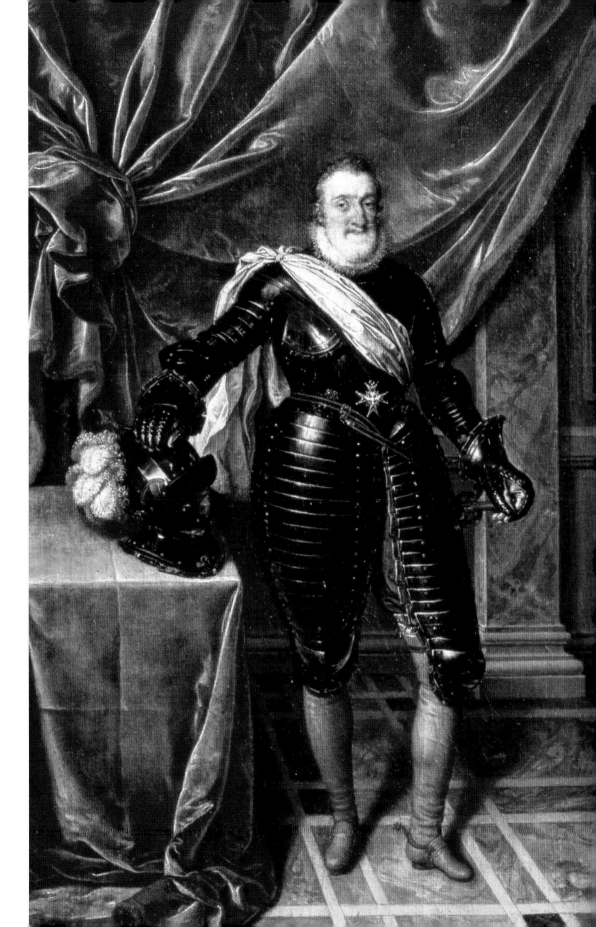

Pl.45, *Henry IV, King of France in Armour*, 1610, Frans Pourbus the Younger, Paris, France, oil on canvas, Musée du Louvre, Paris: No. 1707

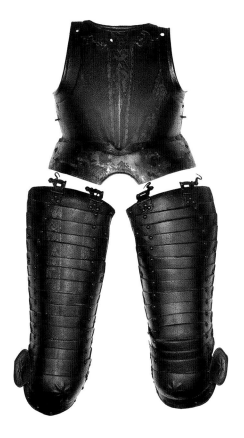

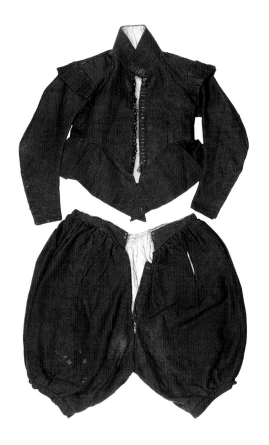

Some things stayed the same. Slashed and pinked fabrics remained popular; once criticized as the work of the devil, they even decorated altar cloths. Delicate, elongated forms inspired women's gloves, whereas gauntlets, their counterparts in armour, became more robust and rounded. Off-the-shelf armour production also stepped up to equip ever more professional armies.

Contemporary writers continued to rail against change. 'I see that the fashion wears out more apparel than the man,' mocked Shakespeare.[60] Trade in imported fabrics, furniture and art, and a greater abundance of printed books and pamphlets expanded horizons. Spreading wealth encouraged the up and coming to acquire the luxuries, lifestyles and manners of the rich. Rearguard actions attempted by legislators were to no avail, and in England sumptuary laws were abandoned in 1604. Portia mocked the new wealth in *The Merchant of Venice*: 'He is a proper man's picture, but, alas, who can converse with a dumb-show? How

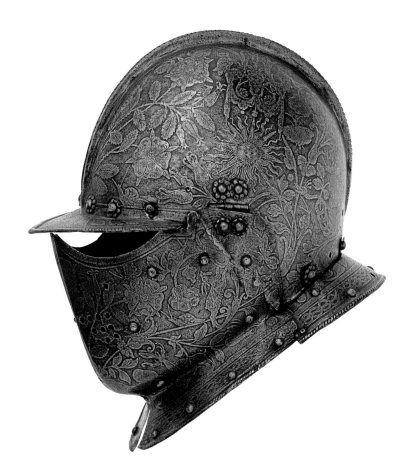

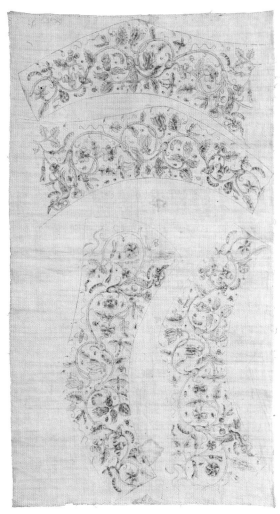

Pl.48, Helmet,
1590–1600, probably
Antwerp, etched steel,
Middle Temple,
London: 75001

oddly he is suited! I think he bought his doublet in Italy, his round hose in France, his bonnet in Germany and his behavior everywhere.'[61]

Thus armour remained fashion-dependent but declined as fashionable dress. Depictions of armour in art reflect this. Still-life paintings declared armour to be symbolic of a declining age. Small armoured components took on the role of accessories. It was these accessories – gorgets, swords, daggers, spurs and pistols – that maintained the image of the man-at-arms.

Pl.49, Uncut sleeve
pattern, c.1600, England,
linen, embroidered in
black silk, H 56 x W
20cm, V&A: 252-1902

Adorning

'For truly, my friend, I am a man of peace, and wear weapons but for fashion.'

The funeral procession moves slowly towards the mausoleum. Sir All in New Fashions is dead (see plate 50).

> *His Breeches, Dublet, Buffe coate, Hatt and Fether;*
> *his Spurres, Bootes, Garters, Gloues, Sword and Dagger;*
> *instead of Flagges; are carried all to geather;*
> *and other toyes, where with he used to swagger,*
> *As Long Coate, Capeles Cloake, Ruffes, fallinge Bands*
> *all fashions Lately brought from forreyne Lands.*

Among those trailing the pall-bearers are his sombre haberdasher, four tailors, his shoemaker, his fencing master, his cutler, his goldsmith, his spur-maker and his feather-maker.

> *Those men who Liud [lived] by him are all amorte;*
> *Liud by him said I; noe, I am mistooke,*
> *He Liud by them:*
> *his names in each mans Booke.*

It was not just the clothes that made the man. A gentleman's sword, dagger, pistol, spurs and plumes punctuated the fashion statements made by his apparel. Decorated weapons were a privilege of the well-to-do, simultaneously the badges of a warrior creed and ornaments of gentility.

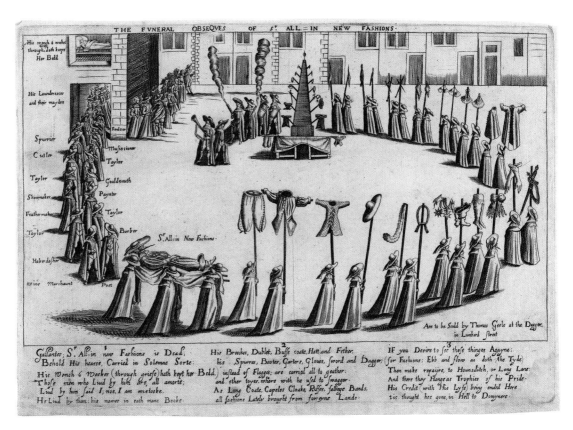

THE FVNERAL OBSEQVES OF S. ALL = IN NEW FASHIONS:

His mouth 6 weekes
through doth keepe
Her Bedd

His Laundresser
and their maydes

Spurrier

Cutler

Taylor

Taylor

Shoemaker

Feathermaker

Taylor

Haberdasher

Wine Marchaunt Poet

Fedlor

Musissioner

Taylor

Gouldsmith

Paynter

Taylor

Barber

S.All=in New Fashions.

Are to be Sould by Thomas Geele at the Dagger
in Lumbard ſtreet

Gallantes; S.All=in new Fashions is Dead;
Behold His hearse, Carried in Solemne Sorte:
His Wench 6 Weekes (through griefe) hath kept her Bedd;
Those men who Liud by him are all amorte;
Liud by him ſaid I, noe, I am miſtooke.
He Liud by them: his names in each mans Booke.

His Breeches, Dublet, Buffe coate, Hatt and Fether,
his Spurres, Bootes, Garters, Gloues, ſword and Dagger;
(instead of Flagges; are carried all to gather,
and other toyes, where with he uſed to ſwagger.
As Long Coate, Capeles Cloake, Ruffes, fallinge Bands,
all faſhions Lately brought from forreyne Lands.

IF you Desire to ſee thoſe thinges Agayne;
(for Fashions: Ebb and flow as doth the Tyde)
Then make repayre, to Hounsditch, or Long Lane:
And there they Hange as Trophies of his Pride.
His Credit with His Lyfe being ended Hire
tis thought hes gone, in Hell to Domynere.

Pl.50, *'The Funeral Obseques of Sir All in New Fashions'*, 1625–30, England, ink on paper, 21.3 x 30.2cm, Bodleian Library, Ashmolean Museum, Oxford, Douce Prints, Portfolio 138, no. 89

Fleeting trends, usually blamed on foreign influences, were a constant target for early seventeenth-century satire. 'The Funeral Obseques of Sir All In New Fashions', itself somewhat ironically an English adaptation of a German print, lampooned the small army of tradesmen a gentleman needed to keep himself up to date. Writers, like the poet John Marston, ridiculed the effeminate dress and warlike accessories of the man about town, who portrayed himself as a warrior but had never been to war.[62] Like the content of a still-life painting, Sir All in New Fashions' belongings were symbols of vanity, of no lasting significance beyond his own earthly conceit.

> IF you Desire to see these thinges Agayne;
> (for Fashions Ebb and flow as doth the Tyde;)
> Then make repayre, to Hounsditch, or Long Lane;
> And there they Hange as Trophies of his Pride.

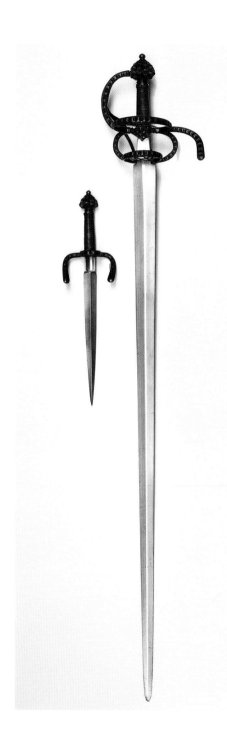

It was not always this way. The conservative English defence expert, George Silver, felt a noble heritage of purpose-made war blades, clubs, flails and maces had been sacrificed at the altar of fashion as swords and daggers became faddish civilian accessories. 'We like degenerate sonnes, have forsaken our forefathers vertues with their weapons.'[63]

Weapons and Identity

While some military swords were worn as costume decoration from the end of the fifteenth century, the rapier and dagger combination were specialist weapons designed for use away from the battlefield. The word rapier probably evolves from the Spanish *espada ropera*, a costume sword.[64] The combination was worn by armed guards, and, as economic development generated wealth for the middle classes, many aspiring gentlemen incorporated the rapier and dagger into their everyday dress (see plate 51). As clothing accessories they were decorated as a set and worn in a fashionable sling called a hanger. Their decoration might also match the spurs on their boots, the pendants around their necks, and the embroidery on their clothes (see plate 52).

Modern audiences do not necessarily gravitate towards weapons in search of beauty, but a different frame of mind existed 400 years ago. Decorated swords were status symbols. They were worthy of the best treatment by jewellers and goldsmiths because they underlined their

Pl.51, Rapier and dagger of the Electoral Guard of Saxony, c.1590, Saxony, steel, the hilt chiselled and blued, rapier: L 113.5cm; dagger: L 38cm, V&A: M.34&A-1948

OPPOSITE
Pl.52, Dudley, Third Baron North, c.1615, England, oil on canvas, H 193.6 x W 133cm, V&A: P.4-1948

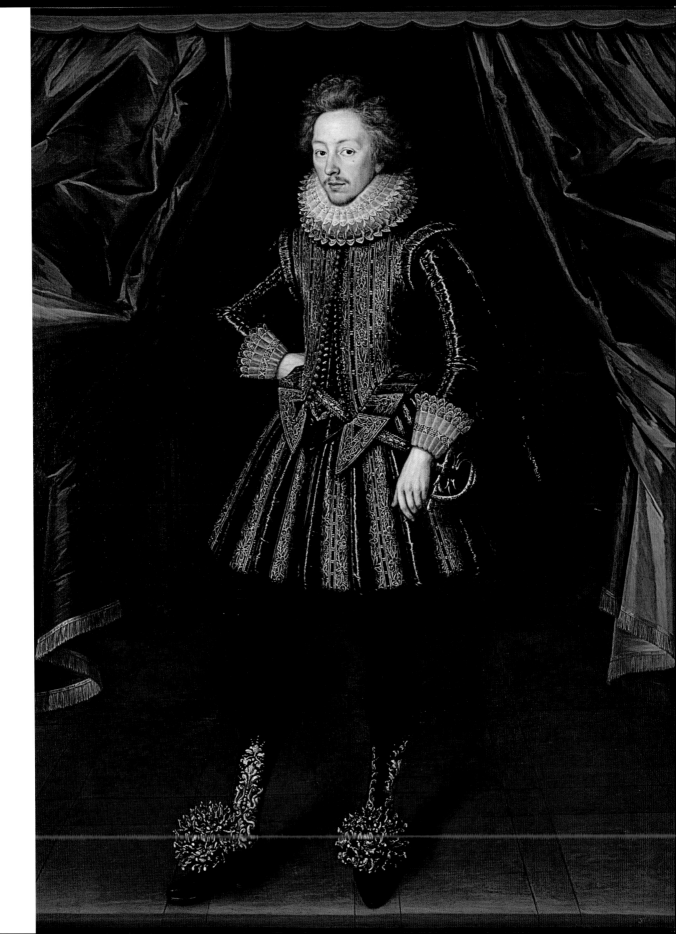

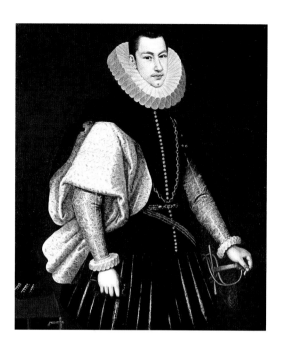

owner's image as strong, successful and fashionable. The French writer François Dancie claimed in 1623 that the sword was the 'finest plume of a great man, without which he cannot be distinguished from a financier, merchant or burgess, whom the abuse of our times permits to be as well-dressed as he'.[65] Inventories of the late sixteenth and early seventeenth centuries tend to group personal weapons with their owner's clothing rather than with the service weapons in the armoury or the Great Hall. An inventory compiled in 1617 at Knole House in Kent of the belongings of the spendthrift Richard Sackville, 3rd Earl of Dorset, listed 'one short sword with the hiltes damasked' and 'one short Crossebar sword being gilte' to be worn with girdles and hangers specified by outfit. The 'paire of girdle and hangers of purple imbroadered with gold and siluer lyned with purple shagge embroadered with starrs' adorned a matching velvet cloak and satin suit with purple silk stockings.[66] When Arthur Throckmorton went to court in 1583, he complained in his diary about the great expense he had to go to both to improve his wardrobe and to have his rapier silvered, even selling off land to finance his appearance.[67]

By the end of the sixteenth century, fewer portraits of gentlemen depict them in armour. Their aspirations and the memory they want preserved are expressed more in their clothes. These portraits celebrate the material rather than the martial successes of their sitters. It is not the face that reveals the character but the wardrobe.[68] However a vestige of the warlike tradition is the frequency with which sword hilts are shown (see plate 53). Attention is drawn to them by the owner's left hand resting gently on the hilt. The scabbard containing the lethal blade is hidden in the shadows, while the hilt – chiselled, gilded and jewel-encrusted – gleams as if shining a light on past and present. It reminds us simultaneously of its owner's status as a man-at-arms and announces anew that he is a man of fashion. The portrait itself could be a relatively small expense after the clothing and jewellery had been accounted for.[69]

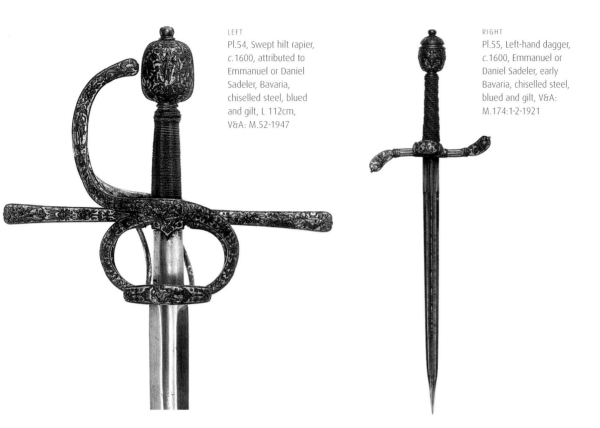

Branded Beauty

Whereas Eastern cultures traditionally emphasize the power, both physical and mystical, of the blade, European history since the sixteenth century has placed greater emphasis on the hilt. Specialist hilt-makers employed in the courts of European princes created products of astonishing beauty and craftsmanship. The Sadeler family of Munich worked for the Dukes of Bavaria, chiselling hilts based on designs by the French engraver Etienne Delaune, and their products are commonly regarded as the finest rapiers and daggers of the period (see plates 54 and 55).

Where there was infinite variety over the designs of the hilts, the blades were most prized for their consistency. During the sixteenth and seventeenth centuries, the sword blades of Toledo, Valencia and Milan were shipped all over Europe, although the finest hilts were usually equipped with a Spanish blade. The

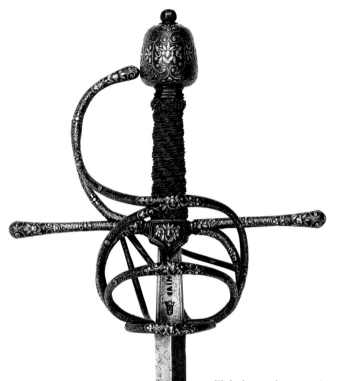

Pl.56 and detail,
Swept hilt rapier, *c.*1600,
England (spurious
Toledo and Milanese
marks), steel, the hilt
damascened in gold and
encrusted with chiselled
silver, L 124.8 x W 22.5cm,
V&A: M.51-1947

Toledo trade was closely guarded. A royal decree in 1567 ordered: '…do not allow or permit to import any kind of sword in our kingdom from the exterior, and the ones made in Toledo wear the mark and signal of the master who made it and manufactured it, and the place where they are made, and whoever violates this they will be condemned as false'.[70] The German town of Solingen produced blades of similar quality to Toledo that sometimes bore spurious Spanish marks and inscriptions. The satirist Robert Greene was on to them: 'And you Cutler, you are patron to ruffians and swashbucklers and will sell them a blade that may bee thrust into a bushell, but to a poore man that cannot skill of it you sell him a sword or rapier new over glased, and sweare, the blade came either from Turky, or Toledo.'[71] Nevertheless, a genuine Toledo mark on a sword blade not only guaranteed its quality but was an early form of brand identity (see plate 56).

Working Jewellery

These status symbols were not simply ornaments. Before the nineteenth-century development of organized police forces it was accepted that men walked around armed and prepared to defend themselves. Rapiers, with sharply pointed blades, were primarily designed for self-defence using fighting techniques developed in Italy that are the ancestors of modern fencing. The sixteenth-century rapier was both a slashing and stabbing weapon. Its accompanying dagger was used in the left hand for parrying and stabbing in close. The stiff slender blades of both were designed to pierce clothing rather than armour.

Jewellery need not be benign. The eighteenth-century presentation small-sword with its flimsy, flexible blade, its hilt bearing the hallmarks of a goldsmith, its decoration of coloured enamels and precious stones, and lengthy inscription celebrating its lucky recipient's role in bloodshed and oppression, has long been accepted as a sophisticated item of male jewellery. Less willingly acknowledged as fashion accessories are the swords and daggers of the Renaissance, possibly because they were able to carry out the violence that their ceremonial descendants commemorated. Losing oneself in admiration for the delicate silver inlays of vines, leaves and flowers on a sixteenth-century sword hilt can lead to feelings of unease when one turns to the business end of the blade.

Rapiers and daggers were designed to kill, but it is unclear how often they did. If Benvenuto Cellini's autobiography is to be believed, his right hand was rarely far from his hilts. Duels ending in death in the early seventeenth century were also quite common. Swords, however, spent most of their time sheathed, their destructive properties hidden from view.

The finest weapons were so lavishly decorated that it is unlikely they were ever intended for use. In 1601, the court goldsmith to the Medici of Florence, Giacomo Biliverti, supplied a sword and dagger whose hilts were set with 680 diamonds.[72] Decorated sword hilts proclaimed the wealth and power of their owners in the same way as a buffet laden with silver cups and dishes. If they failed to elicit due deference, the blade offered an equally well-crafted but far more forceful back-up. Sheathed swords and daggers carried a threat of violence but their first and more frequent impact was visual.

The use of swords and daggers as dress accessories is associated particularly with the period after 1550, a time when elements of armour such as

breastplates and gorgets (neck armour) sometimes performed a similar role. They were manly accessories. Swords have long been symbols of authority and are still in use for conferring honours and titles. The sword of the medieval knight was as personal as his armour and he took it to his grave; his monument or tomb slab preserved his memory by depicting him holding his most trusted weapon. This symbolism honoured not only his first-hand experience of battle but something much more elusive deep inside his character: his valour.

Conversely, the dagger reflected something more humble. It was the gentleman's knife. Knives were practical everyday tools attached to the belts of men of all ranks. A small sheath might contain several knives and tools for hunting, eating, personal grooming and self-defence. For the gentleman, the more expensive and robust dagger was a costume accessory before it joined forces with the rapier. In the Nether Parlor at Wood Hall in Norton-Juxta-Kempsey, Worcestershire, in 1566, William Gower's 'wearing apparell' included '1 damaske gowne, 1 fryse gowne, 1 black saten dublet … 2 payre of hosen of clothe, 1 velvet hatte … 1 payre of velvet shoes, 1 dager, 3 buckles and one jerkyn of Spanishe leather'.[73]

In combination, the rapier and dagger performed a more assertive role. They were worn at court, in procession and about town. They projected an image of honour based on social standing and, if necessary, defended it in one-on-one combat. The private duel was one consequence of the development of the rapier. In this sense, it is the epitome of the new sense of self fostered by the Renaissance. It was an emblem of personal vanity that settled disputes privately.

Form and Use

To fully appreciate the meaning of the sword to the sixteenth-century gentleman, it is important to understand its role as both offensive weapon and costume accessory. As costume jewellery the decorated hilt flowered fully between 1580 and 1620. However, the seeds were sown long before. A 'hand-and-a-half' sword for use in foot combat can be dated to around 1500 based on the decoration of its hilt (plate 57). Held in one or both hands, it is also known as a 'bastard' sword as its grip is not as long as a traditional two-handed sword. The rounded ends of the crossbars (quillons) are quite flimsy, while the finely chiselled pommel recalls the swirling lobes that decorated contemporary flagons and candlestick stems. This appearance demonstrates a move away from the brutal simplicity of the medieval sword.

LEFT AND RIGHT
Pl.57, Hand-and-a-half
sword, *c.*1500–10,
Germany, steel, the hilt
blackened and chiselled,
L 96cm,
V&A: M.603-1927

BELOW
Pl.58, 'The murder-
stroke', *Fechtbuch*,
1467 edition, Hans
Talhoffer, Germany,
British Library, 7905.i.2

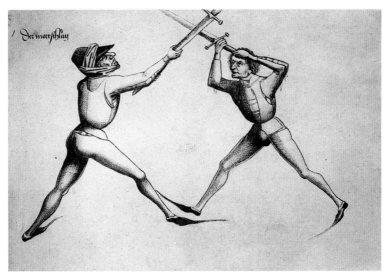

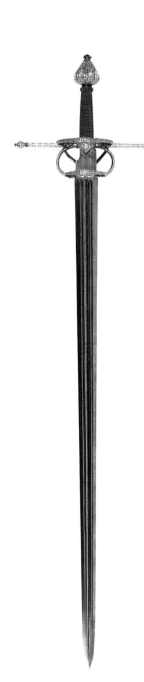

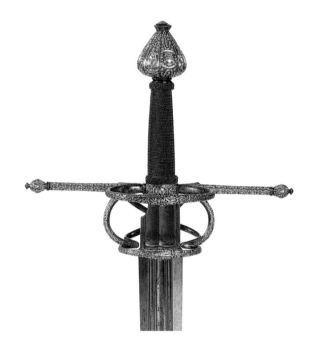

No part of a medieval sword was made without both attack and defence in mind. Modern fencing encourages us to see the blade, in fact only the tip of the blade, as the sole attacking element of a sword, and the hilt more as control room and protector. Tight rules prevent the sword hand ever straying from the hilt and the spare hand from getting involved at all. The fifteenth-century *Fightbook* published by the German fencing master Hans Talhoffer illustrates a more pragmatic approach, as two fashionably dressed men settle their differences using un-decorated swords with thick diamond-section blades (see plate 58). The blades could be gripped as well as the hilt. The rounded pommels at the end of the grip and at the ends to the quillons not only balanced the swing of the sword but acted as hammer-heads to deliver the 'murder-stroke'. As soon as these elements ceased to be functional they took on the role of adornment. The 1500 sword hints at the more decorative hilts produced later in the century.

Civilian swords and battle swords became two separate weapons during the sixteenth century. As armour became heavier in order to defend against firearms, the broad blades of battle swords became sharper to target articulated joins and other areas of weakness. On the battlefield, however, using the sword was increasingly a last resort after guns had been discharged and lances broken.

Even so, military swords might be finely decorated in the latest styles. A sword dating from around 1590 from the equipment of the electoral guard in Dresden is encrusted with silver dancing figures, masks, flowers and chain links on a background of gold (see plate 59). For the date, the plain cross-shape of the sword is quite old-fashioned, although

Pl.59, Military sword, *c.*1570, the blade signed 'MIGUEL CANTERO', Toledo, Spain (blade); Dresden (hilt, probably), steel, the hilt gilt with copper and iron wire and encrusted with chiselled silver, V&A: M.11-1955

this style remained popular in Saxony. The hand that held this sword wore an armoured gauntlet so the sword did not need much protection on the hilt. However, the blade was the sole means of attack, and while a hand encased in metal might still punch effectively with the hilt, it is the hilt's expensive and gleaming decoration, visible at the waist above the scabbard, that first communicates the power of the Dresden court.

Civilian swords were different. Elaborate interlinked bars and rings curving elegantly from the knuckle guard to the pommel created the classic 'swept-hilt' rapier of the late sixteenth century. This offered great scope for the talents of the artist and goldsmith and helped turn the sword into a dress accessory. Chiselled, engraved, inlaid, gilded or silvered, the rapier was an expensive contemporary fashion statement.

A New-fangled Age

Elaborate hilts were not simply trinkets: they guarded otherwise unprotected civilian hands. Just as the rapier itself was in vogue, so was the style of fencing that produced it. George Silver complained in his *Paradoxes of Defence* that 'Fencing … in this new-fangled age, is like our fashions, everie daye a change.' Fencing manuals flooded the market, each professing something slightly different and some translated and republished in many languages. As a product of the Renaissance, these manuals attempted to turn fighting into a science. One of the most influential was Camillo Agrippa's *Scientia d'Arme*, published in 1553 (see plate 60). Agrippa was a mathematician and engineer who understood perspective and applied it, in theory, to the view one might have of an opponent's weapon. His illustrations plotted complicated geometrical drawings of sightlines and body movement to lend the noble art a theoretical and academic framework.

This sat neatly with the all-encompassing education of the Renaissance gentleman, who was expected to be equally proficient an engineer as he was a musician, a botanist, an astronomer, and of course a fighter. Castiglione's *The Courtier* not only advised on deportment and manners but declared that the ideal courtier, 'well built and shapely of limb' with 'strength and lightness and suppleness', should be able to handle every kind of weapon, especially those used by gentlemen.[74] This was a long-held view. Sigmund Ringeck, a fifteenth-century fencing master, claimed knights should 'skilfully wield spear, sword, and dagger

et prefentandola al petto del nemico, & portando il pie deftro con paffo largo, uerfo la parte finiftra de l'auerfario, venne à far circumferenza, con noua profpettiua, & fuggendo il colpo del nemico inueftifce lui nel petto, facendo lo effetto, di G. del quale fi parlò di fopra: anzi l'auerfario volendo fegutare la botta con la fua Prima, da fe medefimo viene ad inueftirfi ne la fpa da cōtraria: D'onde la minor forza potria uincer' la maggiore co come fe detto ragionando per l'opera.

PER dechiaratione di B. et C. notati per le pre cedenti figure, de le quali s'è parlato al fuo loco fimplicemente, per le diuerfita de le botte loro, uē gono à dire adeffo di certi effetti, che ponno proce dere da effe, come fon quefti: volendo C. offender B. potrebbe ancor lui andare in B. & sforzando la fpada contraria fubito feguitar per forza, & feririo di punta nel petto, facendo l'effet to di H. et B. per diffenderfi, et offender C. quando veniffe p sforzarli la fpada, poi che fi foffe pofto in B. per ferirlo come ho detto, Potrebbe parando in fore ferir lui da baffo di riuerfo, oue ro di ftramazon p tefta, o pur di madritto tondo d'alto, et da baf fo: Ma perche la parata è pericolofa per il dar' tempo al nemi co, et per le prefe, come al fuo loco, ne parlaremmo il meglio farà quando C. fia per andare in H. per far l'effetto defcritto, che B. fuggendo la fpada, o per dir meglio fchifandola, vadi in K. per ferir' effo nel petto, ouero fi metta in G. co'l ceder' de là vita, fa cendoli noua profpettiua, ne la guifa che la figura di detto G. fi è vifta. Volendo B. offender C. potrebbe andandoli à la volta del petto fpinger' la fpada, & far l'effetto di H. doue C. pa rando for potrebbe far le medefime botte fopradette, di Riuer fo, Stramazzone, & Tondo: ma p fuggir la parata(come ho det to più volte) tāto pericolofa il meglio farà che C. ritornaifi in B. faccia fubito la botta di H. Cofi ciafcuno di quefti verrà a' diffender fe, & offender' il nemico. Ne fi marauiglij alcuno

Pl.60, Fencers and geometry from Camillo Agrippa, *Trattato di Scientia d'Arme* (Antonio Blado, Rome, 1553) PARTE XXXX, II

in a manly way'.[75] Castiglione's ideal courtier also needed to know how to wear it.

Vincentio Saviolo's *Discourse of Rapier and Dagger*, translated into English and published in London in 1595, saw fencing as an essential element of education. For him, skill in arms was analogous to good citizenship as it prepared a man for the defence of his country. The sword was the weapon of a gentleman, whereas staff weapons, such as the pike, were the unworthy, base implements of the common soldier. Settling 'honourable Quarrels' by rapier and dagger was a noble cause:

Amongst Knightes, Captaines and valaint Souldiours, the Rapier is it which sheweth who are men of armes and of honour, and which obtaineth right for those which are wronged: and for this reason it is made with two edges and one point and being the weapon which ordinary Noble men, Knightes, Gentlemen and Souldiours weare by their side, as being more proper and fit to be worn than other weapons, therefore this is it which must first be learned.[76]

George Silver could not have disagreed more. For Silver the civilian rapier and dagger did not prepare men for the practical realities of battle, where there was 'no room for them to drawe their Bird-spits'. He favoured training with the old sword and buckler, a round shield that could be used for deflecting and guarding. His advocacy of 'ancient teaching, the perfectest and most best teaching' championed striking with a range of weapons and dispensed more practical advice on grips, holds and the timely 'strikinge with the foote or knee in the Coddes'. Rapier-play was too individualistic, ritualized and theatrical to be of any use in war.[77]

The military professional Sir John Smythe scorned soldiers who attempted to take their fashionable rapiers 'of a yard and a quarter long' into battle, and then could not draw them from their scabbards easily and broke them on first contact with armour, their 'being so narrow and so small of substance'.[78] Silver detested its 'foyning', 'frog-pricking' and its 'inconvenient length and unwieldinesse'. He ridiculed those who have 'lusted like men sicke of a strange ague, after the strange vices and devices of Italian French and Spanish Fencers'.[79]

In societies accustomed to settling disputes with violence it might seem a moot point for the rapier to be feared as too offensive. It raised the stakes in a dispute as its blade was too sharp and specialized to offer the range of uses of the older broader swords. While it was derided by some as vain to carry a sword and not know how to use it, other writers were alarmed at the frequency of bloodletting among blade-happy civilians. Modern-day concerns about the fashion for carrying knives echo those raised 400 years ago by William Harrison, who wrote of 'desperate cutters' who 'carry two daggers or two rapiers in a sheath always about them, wherewith in every drunken fray they are known to work much mischief'.[80] George Silver, never straying far from his training-for-battle theme, criticized writers like Saviolo for teaching codes of duelling and methods of offence, as opposed to defence, so that men might 'butcher one another here at home in peace'.[81]

The law was ambiguous. Deaths in fencing schools were treated as collateral damage in the service of the nation, while duels among gentlemen were largely ignored. In Valencia laws were regularly enacted threatening slavery in the galleys for those carrying swords, daggers and firearms in public, but that regularity suggests they were ineffective.[82]

Sumptuary laws tackled the problem by trying to confine the length of weapons according to status. Nobody below the rank of the son of a baron could, according to an English law of 6 May 1562, 'wear any sword, rapier, or any weapon in their stead passing the length of one yard and half a quarter of blade at the uttermost, neither any dagger above the length of twelve inches in blade, neither any buckler with a sharp point or with any point above two inches in length'.[83] The law was an attack on 'long swords and rapiers, sharpened in such sort as may appear to the usage of them can not tend to defense, which ought to be the very meaning of weapons in times of peace, but to murder and evident death'.

The dual role of swords and daggers as weapons and jewellery is shown in an addition to the law made in 1574: 'None shall wear spurs, swords, rapiers, daggers, skeans, woodknives, or hangers, buckles or girdles, gilt, silvered or damasked: except knights and barons' sons, and others of higher degree or place, and gentlemen in ordinary office attendant upon the Queen's majesty's person.'[84] Servants and apprentices wasting their money on decorating weapons they had no business owning not only threatened the peace but risked becoming a financial burden to their parishes.

Lack of prosecutions is not necessarily evidence of ineffectiveness in such laws. John Stowe's *Annales*, or *A Generale Chronicle of England from Brute until the present yeare of Christ 1580*, suggests the law was dispensed without recourse to the courts: the 'greatest gallant, that had the deepest Ruffe, and longest Rapier' was targeted in London by 'grave Citizens, at every gate' who 'cut the Ruffes, and breake the Rapiers points, of all passengers that exceeded a yeard in length of their Rapiers, and a nayle of a yeard in depth of their Ruffes'.[85]

The idea of the dress sword as fashion accessory appalled the purists. Girard Thibault's *Academie de l'Espée* attacked those who 'make the branches twisted upwards or downwards, or curved, the pommels big, round and flattened at the top … all to I know not what show of courage, or rather of cowardice according to the Spanish proverb which says "weighed down with iron, weighed down with fear".' These over-complicated hilts suggested swords served only 'as a simple ornament for one's person rather than as something to be used in time of necessity'.[86]

For Phillip Stubbes, the widespread craze for the sword as accessory was a symptom of a society changing fast. How could one know how much deference to offer if traditional social distinctions were breaking down? What should be done

about 'inferiour sorte' who wore rich fabrics 'with their swoords, daggers, and rapiers guilte and reguilte, burnished, and costly engraven, with all things els that any noble of honorable, or worshipfull man doth, or may weare, so as the one cannot easily be discerned from the other'? All swords 'clogged with gold and silver' offered were 'a great shewe of pride … an infallible token of vain glorie, and a greevous offence to God'.[87]

The sharpest words thrust at the heart of this fashion were written by the satirist Robert Greene. In *The Scottish History of James the Fourth* the foppish Slipper demands a blade with 'a very fair edge' … 'Because it may cut by himself, for truly, my friend, I am a man of peace, and wear weapons but for fashion.'[88]

Greene expanded this theme in *A Quip for an Upstart Courtier* in which he discussed 'A quaint dispute between Velvet breeches and Cloth Breeches, Wherein is plainely set downe the disorders in all Estates and Trades.' He launched an attack not so much on luxury and display but on those who ape the manners of their betters. His target was 'not the apparell when 'tis worthily worne but the unworthy person that weares it'. He recounted a dream in which he assembled a jury of artisans and tradesmen to pass verdict on the cloth breeches' perceived disrespect towards velvet breeches. The velvet breeches – in fact 'a very passing costly pair of Velvet-breeches whose panes being made of the chiefest Neapolitane stuffe … drawne out with the best Spanish Sattin, and marvellous curiously over-whipt with gold twist, interleaved with knots of pearle' – were adjudged to be 'an Upstart, come out of Italy, begot of Pride, nursed by Self-love and brought into this countery by his companion Newfanglenesse'.[89]

The woodcut illustration on the frontispiece depicts the two main characters (see plate 61). But how does one differentiate the velvet

Pl.61, Title page from Robert Greene's *Quip for an Upstart Courtier* (first printed 1583; this edition 1620), London, England, woodcut; ink on paper, V&A, Dyce Collection 25.C.46

from the cloth in a two-tone woodcut? Velvet-breeches is distinguished by his ruff and rapier, the ornamentation of a gentleman.

Fire and Steel

If the rapier and dagger combination struck fear into peaceful citizens, it was as nothing compared with the carrying of firearms. Most guns were too cumbersome ever to be classed as jewellery, status symbols though they were. By the late sixteenth century, however, pistols were small enough to be carried in the palm of the hand, to be worn on a belt or, to the alarm of the authorities, be concealed in a cloak (see plate 62).

Pl.62, 'A Mounted Gentleman' from *A True Description of All Trades*, Jost Amman, 1568, National Art Library 307.F.30

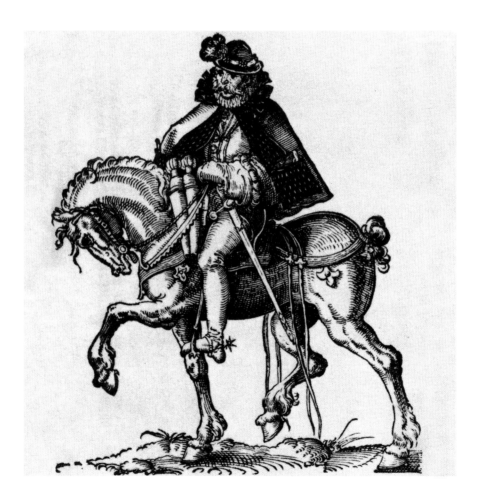

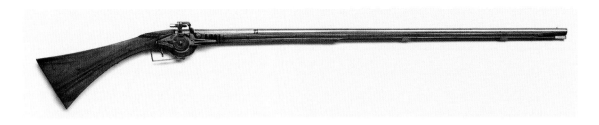

Their popularity was initially due to a new firing mechanism that made them more efficient and portable. The wheel-lock was a circular, spring-loaded device wound with a spanner to high tension. When the trigger was pulled, a clamp holding a small block of iron pyrites against the spinning wheel created sparks that ignited the pan. Sketches for wheel-locks were made by Leonardo da Vinci, but their first common use was in Germany in around 1520. They were the first devices to enable guns to fire mechanically, and accelerated the development of firearms by negating the need for long and dangerous match-cords that had to be kept dry. Guns could be carried loaded and ready to fire. Wheel-locks, along with the development of increasingly powerful gunpowder, encouraged smaller guns, including the pistol.

As technical devices, wheel-locks attracted princely collectors. Many were finely chiselled and engraved as works of art, even on their insides, to be taken apart and reassembled at leisure. The stocks were also often decorated with fine bone and horn inlays, drawing on the skills of furniture makers and engravers. The Emperor Charles V had a collection of handguns in the 1540s, although Louis XIII, seventy years later, is usually regarded as the first systematic gun collector (see plate 63).

Pl.63, Wheel-lock musket made for Louis XIII, *c.*1620, Paris, carved pearwood with iron mounts, 121 x 18.8cm, V&A: 603-1864. The gun is stamped with the number 5, an inventory number from the *Cabinet d'Armes* of Louis XIII, King of France (1610–42).

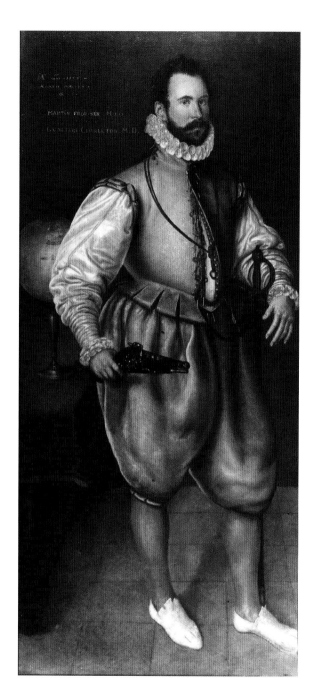

Wheel-lock guns were expensive, however. On the battlefield, gun-toting cavalry were largely members of the aristocracy and more or less superceded the old medieval knights carrying lances. Squadrons of riders charged in line on horseback and discharged their pistols in unison, before wheeling round to be followed by a second line. 'One could see nothing but fire and steel,' wrote the French captain Blaise de Montluc.[90] Ordinary gunners had to make do with older style match-lock guns until well into the seventeenth century. As fashion accessories, particularly for the military man, guns paraded not only bravado, but an up-to-date knowledge of strategy (which itself was subject to fashion changes) and the wealth to afford the equipment (see plate 64).

It was not just the guns that were expensive. A range of accessories was required to operate and maintain them, including spanners for the mechanism, measured charges, powder flasks and priming flasks (see plate 65). These too were often painstakingly decorated to match the gun (see plate 66). Some were fitted with suspension loops for attaching to a bandolier, a type of sling worn over the shoulder or around the waist, similar to a sword belt. They have distinctive fronts and backs, the former often highly decorated, the latter plain

Pl.64, Sir Martin Frobisher, 1577, Cornelis Ketel, England, oil on canvas, Bodleian Library, Oxford

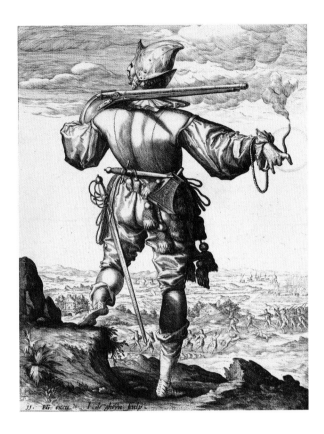

to rest against the body. Powder flasks and cartridge boxes at their finest are exquisite items of jewellery, designed as much to enhance personal appearance as to feed destruction (see plates 67, 68 and 69).

Firearms never completely caught on as fashion accessories in the way rapiers did, partly because the law was a little less ambiguous when it came to dealing with them. Sixteenth-century firearms are sometimes dismissed as not being very accurate. That was not entirely the point. They were designed for concentrated fire in groups rather than individual sniping. Close-up there was no answer to them. William Harrison complained that attacks on the highways by robbers carrying long staves, presumably longer than the rapier blades that might oppose them, encouraged people to carry guns.[91]

Whereas longer swords were restricted according to status, confining their use to the most respectable, it was the smaller guns that the law tried to ban out-

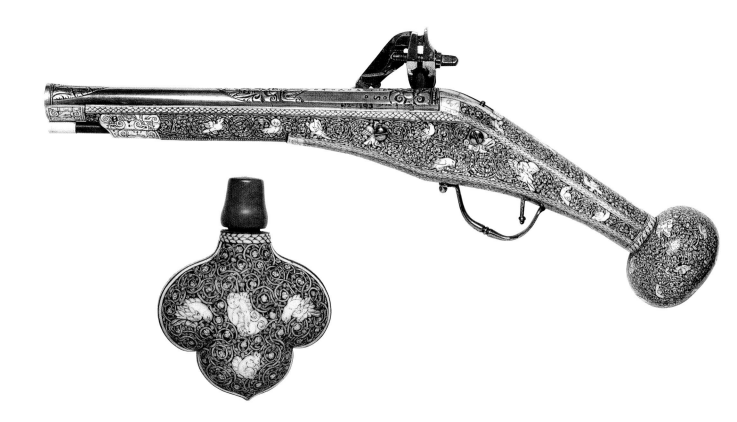

Pl.66, Wheel-lock pistol
and powder flask, pistol
dated 1579, southern
Germany, chiselled and
engraved steel, walnut
inlaid with antler,
55 x 8cm (pistol),
11.8cm (flask)
V&A: 612-1893, 67-1903

RIGHT
Pl.67, Powder flask,
early 17th century,
Saxony, carved ebony
with engraved silver
mounts,
14.6 x 10.6 x 3.2cm,
V&A: M.2741-1931.
The flask is carved with
a hunting scene.

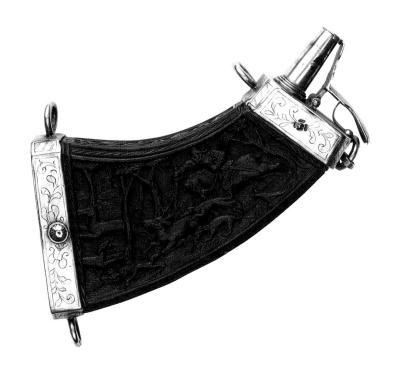

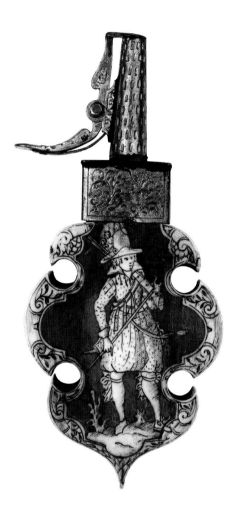

right. A sword proclaimed its threat from the hip and presented a visible danger. A wheel-lock pistol could be concealed, ready to fire from distance, until it was too late to react. It also required little training or skill to be deadly. In 1518, very early in the history of wheel-locks, the Emperor Maximilian I attempted to abolish 'self-igniting handguns that set themselves to firing'.[92] Any gun small enough to fit inside a sleeve was banned in Venice in 1542. A law introduced by Elizabeth I in 1579 described pistols as 'in time of peace only meet for thieves, robbers an murderers'.[93] Elizabethan fears were well-founded: seven years later Prince William of Orange was shot dead, the first head of state assassinated with a handgun.

Collecting

'What sound acquaintance can there be betwixt Mars and the Muses?'

Building a collection of armour and weapons, even on a small scale, was a practical means of protection, but above all it was a family's declaration of wealth and power. Such collecting was not an isolated activity, but part of a fashion that encompassed all the arts and natural sciences (see plate 70). A visitor to Ambras Castle, near Innsbruck, in the 1580s might have thought the whole world had been compressed into a single place, so extensive were Archduke Ferdinand's collections of gold, silver, armour, precious rocks, minerals, corals, exotic animal specimens and other curiosities.

These collections reflect a broadening European interest in what the world had to offer, and a growing awareness of people's place in it. In Prague, among Emperor Rudolph II's treasures, was a huge collection of scientific instruments denoting his interest in mathematics and astronomy. By the sixteenth century a good understanding of nature, mathematics, literature, music and painting were all aspects of education that, alongside hunting skills and martial prowess, helped to denote nobility.

At Ambras, Ferdinand's pride and joy was his collection of arms and armour.[94] It occupied three times the space of the rest of the collection and was famous during his lifetime. It was also the first to be arranged systematically. In the 'Rustkammer' (Armoury) were displays illustrating tournament armour incorporating equipment previously owned by the Emperor Maximilian I. The 'Heldenrüstkammer' (Gallery of Heroes) was the focal point of the collection, with armours belonging to famous commanders displayed near to their portraits (see

Pl.70, 'Sense of Touch' from the 'Allegory of the Senses', c.1617, Jan Brueghel the Elder, Peter Paul Rubens, oil on canvas, 65 x 110cm, Museo Nacional del Prado, Madrid, No. PO1398. This fantasy landscape filled with paintings and armour is from a scene depicting various natural and man-made wonders symbolizing the five senses.

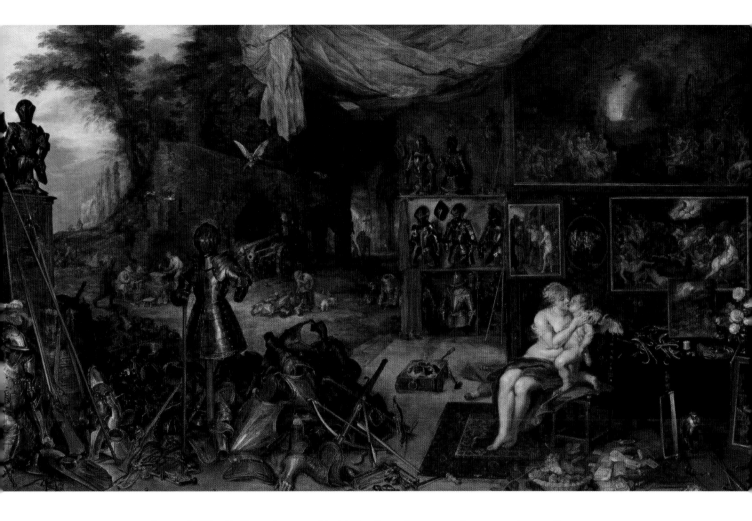

plate 71). The 'Leibrüstkammer' held Ferdinand's personal armour. A tour for a visiting dignitary would take in the three rooms before heading into Ferdinand's cabinet of curiosities. Ferdinand, a proud Habsburg, aimed to glorify, almost deify, his family with his palace and collections. Many of the armours can be seen at Ambras today, in pristine condition, some mounted on sixteenth-century mannequins, others in their original showcases.

Armour and weapons collections were nothing new in the sixteenth century, but their arrangement in this manner was. Perhaps more typical, although not so extensive, was the slightly chaotic scattering, according to an inventory of 1492,

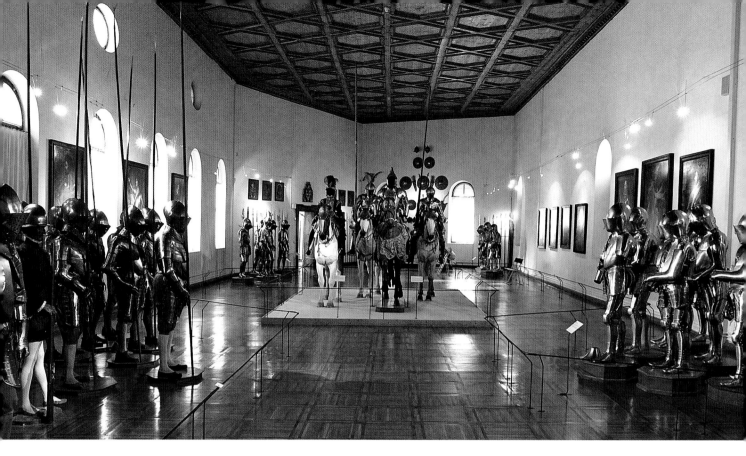

of weapons belonging to Lorenzo 'The Magnificent' left in chests, cupboards and beside the beds all round the Medici Palace in Florence.[95] Storing weapons in the halls of English houses was also common, but Ferdinand collected deliberately and with an eye to completeness and display. In 1576 he asked the Elector August of Saxony to bequeath him the armour he and his brother Moritz had worn at the siege of Gotha to add to his collection.

Great armouries, alongside treasuries, were also developed in the sixteenth century in Madrid, Dresden and London. In many ways they were the forerunners of today's great museums, although the collections were still 'used'. At Dresden, the court of the Electors of Saxony, the old family castle underwent several major renovations to turn it into a princely residence, including the construction of a new armoury with easy access to the tournament yard. The palace was a centre for entertainments such as grand pageants, jousts and hunts.

The Dresden armoury had an official administrator by the 1540s. Its collections were enormous: they spread over thirty-two rooms, each arranged themat-

ically, including the Black Horseman's Chamber, in which there were fifteen carved wooden horses equipped with full armour, and the Hungarian chamber showing sabres, daggers, maces, Turkish bows and firearms. In the Electoral Chamber were the private weapons of the electors, including the most precious dress-swords and daggers. An inventory of the collection drawn up in 1606 ran to 1,602 pages.[96]

Assembling and showing a great armoury was one way to memorialize a prominent family and to emphasize its authority based on its glorious tradition and inherited right. The top floor in the Long Corridor at Dresden was set up as the ancestral gallery of the Wettin family, Electors of Saxony, and contained frescoes and portraits depicting heroic deeds in wars and tournaments past.[97]

With armour, the memorial could be highly personalized. As good armours were made to measure, they represented known individuals and could not be worn by anyone else without alteration or padding. At Ambras, a 2.6m high mannequin represents Bartlmä Bon, a peasant who, because of his exceptional size, attended a tournament in Vienna in 1560 as a talisman for the nephew of Archduke Ferdinand. The mannequin wears Bon's Landsknecht armour and clothing and stands in the same place as it did in the sixteenth century.[98]

Grand display armouries, with their deliberate arrangements trumpeting the achievements of great dynasties, were a form of theatre. A visiting dignitary was effectively acting in a controlled performance when being shown around. Armouries were treasure houses, at least as important to the image of a nobleman as his collections of silver, sculpture and painting. So rich were the collections in Dresden that an envoy from Augsburg in 1629 felt he had 'neither the eyes, the time, nor the brains enough to observe and take it all in'.[99]

Owning an armoury of martial treasures was a widely held aspiration for those who could afford it. The clergyman William Harrison claimed to have seen an English baron's armoury containing over a hundred armours and a plethora of firearms 'the very sight of which appalled my courage'.[100] Even lesser houses might contain small arsenals of weapons, some of which were kept as treasures. Inventories of English houses during the late sixteenth and early seventeenth centuries place the service weapons either in the hall or in a separate armoury where they were accessible. The personal weapons of the owner were kept in more intimate rooms. While his armoury at Earls Croome, in Worcestershire, contained 'the armour, the coats of male, the jackes, saddles, trunckes … and othertrumperie',

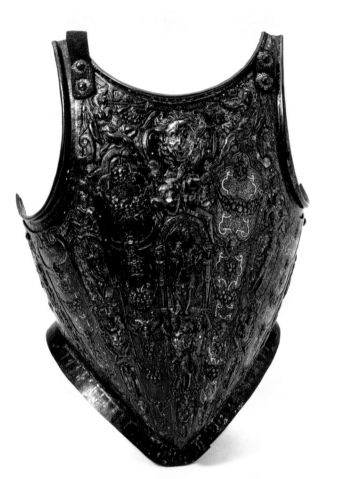

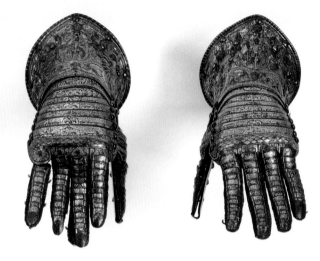

Leonard Jefferies' bedchamber housed 'his wearing apparrell' and 'a crossbow, five pictures, twoe muskettes, a murderinge peece, a targett and buckler, … three swordes, a dagger, certein staves and some papers, little boxes', as well as an astrolabe, three watches, his bracelet and rings.[101] In 1621 Sir Thomas Bigge of Lenchwick, Worcestershire, kept his prized weapons, 'twoe petronells, a dagge, a pistoll, a dagger, a skayne', in his study.[102]

One of the most effective ways to honour one's host was with gifts of armour and weapons to add to his collection. Several of the V&A's finest pieces of armour fall into this category. A boy's breastplate and a pair of similarly decorated gauntlets survive from armours presented by Charles Emmanuel I, Duke of Savoy, to the Spanish royal family (see plates 72 and 73). The Duke married Philip II's daughter, Catherine, in 1585, and the armour was probably intended for her eight-year-old half-brother, the future King Philip III.[103]

LEFT AND ABOVE
Pl.72, Breastplate and gauntlets, c.1585, probably from the workshop of Lucio Marliani (known as Piccinino), Milan, Italy, steel, embossed and damascened with gold and silver, 45.5 x 33.4 x 23.0cm (breastplate), V&A: 144-1921; H 11.8 x L 24.8 x W 14.2cm (gauntlets), V&A: M.143&A 1921. Possibly from a series of armours presented to the future Philip III of Spain by Charles Emmanuel, Duke of Savoy.

OPPOSITE
Pl.73, Allegory of Education of Philip III of Spain, 1590, Justus Tiel, oil on canvas, 159 x 105cm, Museo Nacional del Prado, Madrid: 1846

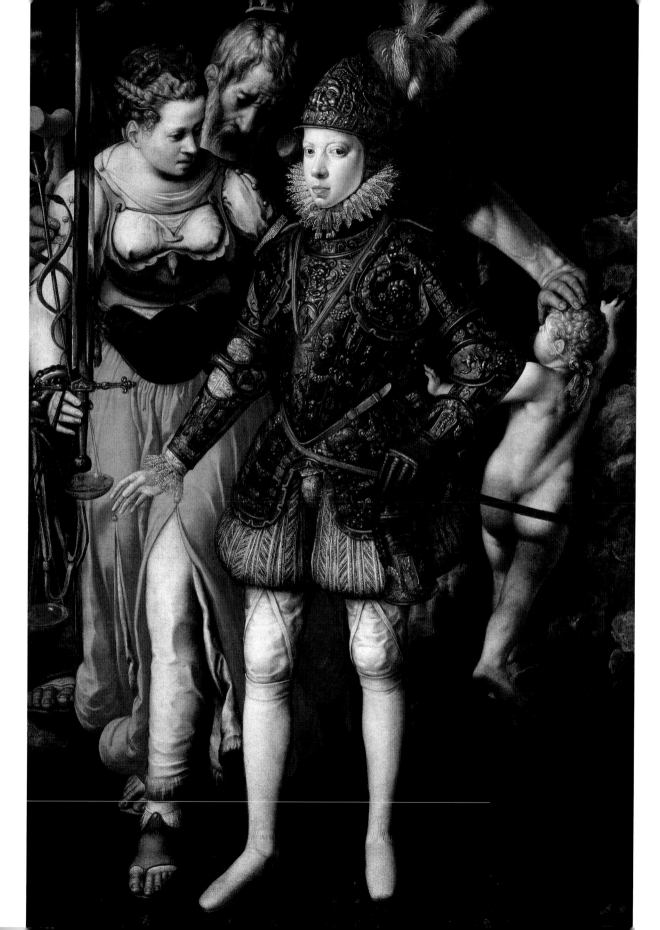

Commissioning a gift of armour for a boy was costly as he would soon grow out of it, but Emmanuel spared no expense. The breastplate, of fashionable peascod form, is crisply decorated with strapwork and grotesques supporting figures of Mars, Fame and Victory, topped by a Medusa's head. The gauntlets are finely articulated with up to fourteen separate overlapping plates per finger, and the iron surfaces are overlaid with gold and silver. The pieces were probably made by the important goldsmith-armourer Lucio Marliani (known as Piccinino) of Milan.

Not only did armouries contain items for the personal use of ruling families but also large sets of equipment needed for their bodyguards. These were not merely functional weapons but highly decorated and sometimes ceremonial expressions of the households they protected. A halberd in the V&A's collection is a good example of a weapon that has evolved from a rugged tool of war into a sophisticated symbol of established authority: a symbol of peace (see plate 74). On the battlefield, a halberd was a serjeant's multi-purpose enforcer, a long handled axe descended from agricultural implements. Its spikes, blades and hooks were designed to entrap opponents and pierce armour, and its staff could be used for keeping one's own regiment in order. In the 1550s, Agrippa's fencing manual still advocated full training in its use (see plate 75). On the V&A's example, however, the hooks have become decorative loops and the blade is elaborately etched with the arms of Wolf Dietrich von Raitenau, the art-loving, architecture-reforming, Arch-Bishop of Salzburg. Several of these halberds are preserved in European collections, particularly in Salzburg, along with painted leather 'watchmen's' shields, of which two are also in the V&A.

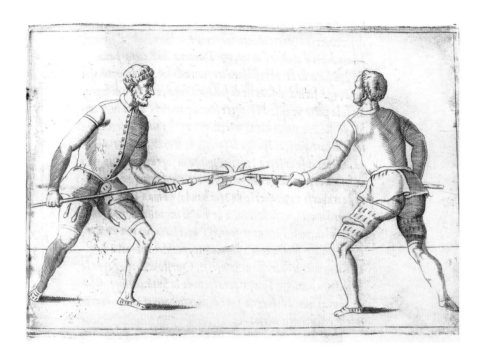

Demanding Patrons

'What hath the long black gown to do with glistering armour?' wrote the clergyman William Harrison of his reluctance, in his *Description of England*, to discuss military matters with which he was 'nothing acquainted'. 'What sound acquaintance can there be betwixt Mars and the Muses?'[104]

To understand the history of armour and weapons during the Renaissance it is as important to see them in the context of artistic production as it is to focus on their practical roles in war, tournament and hunt. By the end of the sixteenth century, for a nobleman keen to portray a heroic image, the decoration of parade armour was as important as its construction. The appearance of all-over armours became as much the product of the goldsmith as the armourer. Art history often places the maker at the centre, but craftsmen responded to requirements set by patrons.

The technical demands made of armourers, swordsmiths and gunsmiths were considerable. Specialist craftsmen had to adapt established designs, that may have been published in plain rectangular form, to awkward shapes. These might

form a range of components in a variety of materials which then had to be assembled to create a single piece. This in turn had to perform a complicated technical role, and in the case of swords, crossbows and guns, withstand powerful, sometimes explosive, forces.

Designs

Inspiration for design and ornament usually came from finished objects, models and prints. Some of the most celebrated artists of the Renaissance worked in far wider areas than those for which they are now best known. The Nuremberg artist Albrecht Durer initially trained as a goldsmith before becoming a painter and printmaker, and part of his huge output included designs for parade and tournament helmets as well as a sword fighting manual, *Fechtbuch* (Fightbook). Hans Holbein, Henry VIII's court artist, designed elaborate gold cups and sword hilts mounted with precious stones. Daniel Hopfer, from an Augsburg family of prolific portrait and printmakers, was primarily an armour decorator and is credited with introducing etching in printmaking, a technique he first applied to armour.[105]

Printed designs were still relatively new in the early sixteenth century, but they were cheap and portable. Some showed detailed designs for objects, while others reproduced bands of ornament that could be adapted to a range of materials, shapes and techniques. The French artist Thomas Geminus published *Morysse and Damashin renewed and encreased Very profitable for Goldsmythes and Embroiderars* in 1540, promoting in England the widespread European fashion for Islamic-inspired interlace (see plate 76).[106] Although his market may have been stated as goldsmiths and embroiderers, these densely packed, stylized leaves and vines arranged in geometric patterns were useful to architects, leather bookbinders, glassmakers and, of course, armourers (see plate 77).

Innovations in military technology presented opportunities for artists and goldsmiths: no new equipment was immune from their influence. The flat sides of flasks and boxes needed for storing gunpowder and cartridges were particularly lavish. A Flemish powder flask of around 1580 compares closely with a flask design recently attributed to Etienne Delaune, who worked for the court of Henri II of France (see plates 78 and 79).[107] Delaune was a goldsmith whose designs ornamented silver and pewter buffet dishes and were widely adapted for armour and weapons.

Pl.78, Powder flask,
*c.*1580, probably
Antwerp, velvet-covered
wood mounted with gilt-
embossed iron with
etched and gilt mounts,
29.3 x 24.1 x 7.5cm,
V&A: 681-1864

Pl.79, Design for a
powder flask, *c.*1580,
Wendel Dietterlin the
Elder, Strasbourg, pen
and brown ink, blue-
green and pale brown
wash, 18.6 x 26.8cm,
Metropolitan Museum
of Art, New York: 46.56

Gunmakers in particular were flexible in incorporating several designs to single pieces. Their works blur regional boundaries. A holster pistol inlaid with allegorical figures, plants, animals and birds using designs by the Swiss woodcut artist Jost Amman and the Flemish engravers Theodor de Bry and Hans Collaert highlights the international nature of weapon design after the establishment of printing (see plate 80).

Portable and reusable plaques of lead, plaster, bronze and other materials were also a useful means of transferring designs from one medium to another. A small priming flask, dated 1574, made for the bodyguard of the Bishop of

Pl.80, One of a pair of wheel-lock holster pistols and detail, 1600–10, Germany, steel, walnut inlaid with engraved antler and ivory, 76.2cm, V&A: M.232-1919

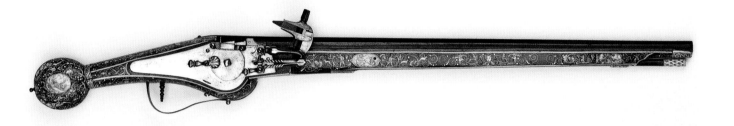

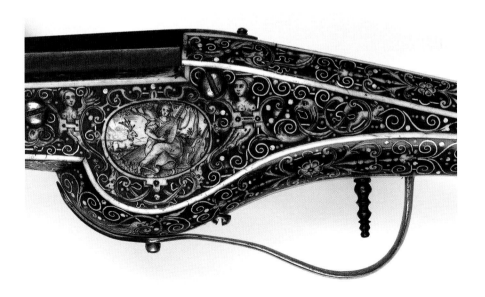

Würzburg is cast with figures from a series of plaquettes depicting ancient German kings by the Nuremberg sculptor and medallist Peter Flötner (see plate 81). Further kings from the series appear on a gilt bronze handbell (see plate 82). Plaquettes were used like pattern books. They were arranged in lines and a clay or plaster mould was made from them. In these moulds, wax models were cast which were then applied to the outside of the wax models of bells, mortars, flasks and tankards before they were cast in metal. Flötner's workshop catered for armourers, bell-founders, goldsmiths, pewterers and medallists.

The extraordinary inventions and levels of creativity of Renaissance designers were balanced with pragmatism. Like all workshops, they needed to earn a living. Producing designs that could be adapted to a range of uses made economic sense. Filippo Orsoni's album of designs for armourers, produced around 1554, contains drawings whose captions openly touted for business. 'Here follow 40 sheets of different hilts for cavalry or infantry for falchions and scimitars, very

fine designs. All different, they can be copied by armourers and they will facilitate their work.' (see plate 83)

The diverse materials and techniques used to decorate armour and weapons bears witness to their importance as treasures and heirlooms. Several artisans with specific skills might be required to make a single object. Most were specialists in particular techniques rather than in types of weapons, so the goldsmith who decorated a sword-hilt might also ornament more domestic items such as clocks and caskets.

Etching

Etching creates a characteristic two-dimensional surface decoration of geometric shapes with sharp edges, to contrast with plainer areas of polished metal. It was used as ornament for both fighting and parade armour from the late fifteenth century. The blades of ceremonial weapons in the late sixteenth century were also commonly decorated this way.

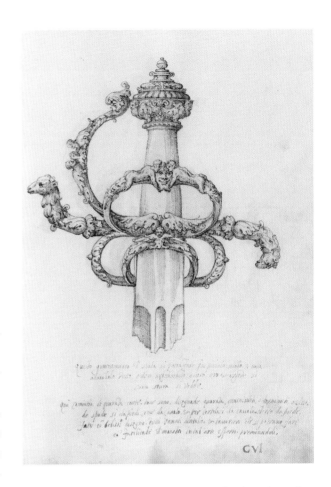

Pl.83, 'Forty sheets of different hilts' from an album of designs dated 1554, Filippo Orsoni, Mantua, Italy, pen, ink and wash, 41.9 x 28cm, V&A: E.1725-2031-1929

The technique involves coating an already formed object with an acid-resistant substance such as wax and then engraving the wax with the desired pattern to reveal the metal underneath. The exposed areas of the metal are then eaten away when the entire surface is coated with acid, so that when the wax is removed a low-relief impression is left on the metal. This was usually blackened to increase the contrast.

'Arabesques' and 'moresques' appear frequently, particularly on armour produced in Brescia in northern Italy, reflecting the area's proximity to Venice and its trading routes to the east. These patterns particularly suited the decoration of both etched armour and embroidered clothing as the effect is two-dimensional.

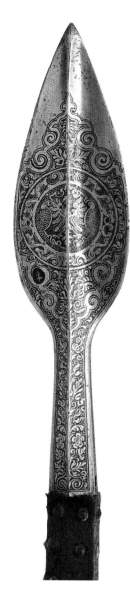

Pl.84, Blade of a boar
spear, c.1580, southern
Germany, etched steel,
32 x 8.2cm (blade),
V&A: M.30-1952

Pl.85, Casket,
1580–1600, Germany,
etched steel,
V&A: 744-1893

Low-relief etching made it possible to create highly decorated armours without affecting the structural integrity of the metal.

Etching is perhaps best preserved on ceremonial weapons which have not been subject to as much wear and tear as armour, such as the V&A's boar spear of around 1580 (see plate 84). Decorative spears like this were deemed worthy of a place in an armoury alongside ceremonial halberds and pikes. More functional boar spears had cross-bars behind the blade which kept the hunter beyond the reach of sharp tusks by preventing the spear penetrating too deeply.

In the Dresden armoury the frames of gunpowder flasks were etched in a style that also decorated the Elector August's gardening and carpentry tools.[108] Etched ornament, pioneered by armour decorators, also adorned jewel caskets and locks (see plate 85).

Embossing

Embossing involves tracing a design onto the surface of an item and then working it from the reverse into contrasting areas of high and low relief using hammers and punches. 'Chasing' or pressing the metal using a fine tool called a burin completed the complicated detail on the front. Embossing was a risky process with armour as it stretched the metal, although in certain cases creating deep corrugated ridges and troughs may have added strength to it.

The highly ornate embossing common in the later sixteenth century is often described as 'goldsmiths' work'. Embossed shields in particular resemble the great silver basins that decorated the buffets of the wealthy (see plate 86).

Such armour offered no protection; that was not its purpose. A shield inscribed 'JÖRG SIGMAN, GOLDSMITH OF AUGSBURG, COMPLETED THIS WORK ON 27TH AUGUST 1552' is a prime example (see plate 87). The shield is richly decorated with scenes from the history of Rome. From its central boss a high relief Medusa's head stares out, recalling the legend of Perseus killing the fearsome monster whose gaze had turned her enemies to stone. Some of the figures occur in a work on Roman coins and medals published by Eneo Vico in 1548 called *Le Imagini ... degl' Imperatori tratte delle Medaglie*. Prints by the Hopfer family may also have been used for the trophies of armour.[109] This type of densely packed ornament awash with intellectual references is sometimes known as 'Mannerism', a technically and visually demanding style requiring virtuoso craftsmanship.

The shield is a work of art, made for display rather than battle. Its maker, Jörg Sigman, was a goldsmith who decorated armour for the celebrated armourer Desiderius Helmschmid. Their clients included Philip II of Spain. Before serving as a display piece, the shield was probably intended for use on parade, and may relate to an armour in the Hofjagd und Rüstkammer in Vienna. It is effectively a picture in iron, so boldly embossed the metal has been stretched to breaking point. Its weakness as a piece of armour is its strength as a work of art.

ABOVE
Pl.86, Ewer and basin,
c.1580, Venice,
Italy, silver-gilt,
43.9 x 16.6cm (ewer);
67.5 x 7.5cm (basin),
V&A: M.237&A-1956

RIGHT
Pl.87, Shield, dated
1552 and signed by
Jörg Sigman, Augsburg,
embossed steel, wax,
61.2cm diameter
V&A: 3660-1855

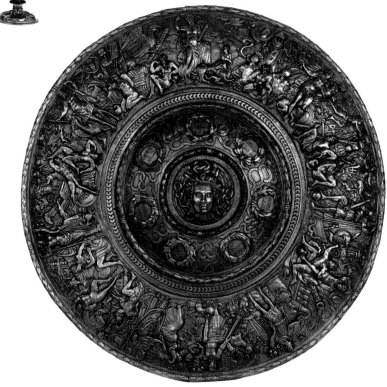

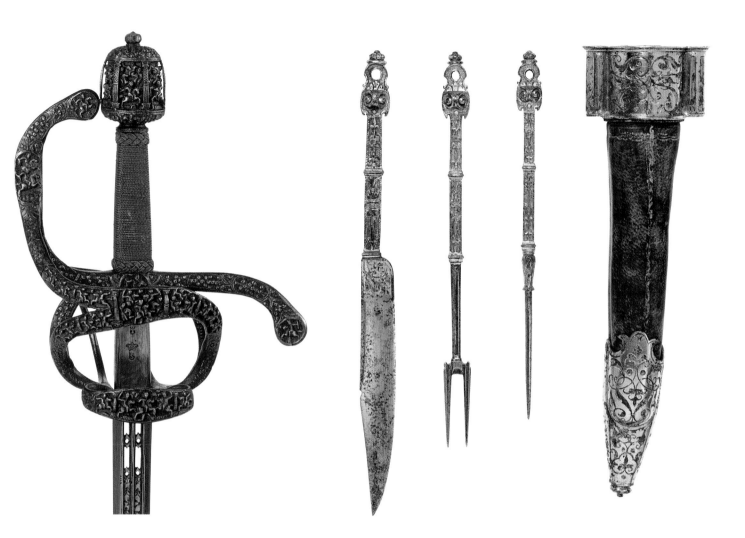

Steel-chiselling

Chiselling steel was highly skilled work that at its best produced sword hilts, gun-locks, cutlery and caskets remarkable for their crisp and clean decoration (see plates 88 and 89). So durable is hard steel that many items retain much of this crispness to the present day. Northern Italy was a centre for this work, but high-quality chiselling also came out of France and southern Germany. In Munich, Ottmar Wetter and the Sadeler brothers, Emanuel and Daniel, produced swords for the Bavarian court at the turn of the seventeenth century that are a high point in the history of European sword-hilt making.

One of the finest swords in the V&A's collection is a rapier with a colonnade and figures on horseback chiselled on the hilt. The pommel, the rounded knob at the top of the hilt, is carved from a single block of steel. One might expect such elaborate work to be produced by casting so that it could be repeated easily, but so undercut are the various elements in the decoration that one would not be able to release a mould in the process. Even so, this style of hilt was produced in reasonable numbers, and highlights the international nature of the sword trade. Several of these hilts made in northern Italy survive in the great armoury at Dresden, in Saxony, where they were fitted with blades from Toledo in Spain.

Damascening and Encrustation

Damascening was extremely popular on north Italian armour of the second half of the sixteenth century, especially embossed parade armour produced in Milan. It is recognizable by the intricate patterns of gold and silver wire on the surface of darkened iron and steel. Sometimes the wire is inlaid in engraved channels, but more commonly it is overlaid and rubbed and hammered on. Occasionally the ornament sits proud of the surface and is more like an encrustation.

A pair of stirrups in the V&A demonstrates the intricacy of damascening at its best (see plate 90). On the outside, intertwining vine leaves of predominantly gold contrast with the more stylized silver 'arabesque' leaves on the inside. Traditionally, the stirrups have been related to an armour made in 1546, for Duke Guidobaldo II of Urbino (see plate 26), although this attribution has recently been questioned.[110] The armour, in ancient Roman style with very similar vine-leaf decoration, was the work of the goldsmith Bartolommeo Campi of Pesaro. Decorating armour this way was no mean undertaking. Campi boasted in the inscription on the breastplate that he completed the work 'in two months in order to obey the wish of his prince, even though it needed a full year'.

As the name implies, damascening originated in countries to the east of Europe, particularly Syria (Damascus), Persia, Egypt and Turkey. Imports of Islamic goods through Venice gave north Italian craftsmen plenty of inspiration when decorating anything from brass dishes to hand-warmers, from inkstands to candlesticks, and from breastplates to sword hilts (see plate 91). The great Florentine sculptor and goldsmith Benvenuto Cellini described his 'burning desire' to try his hand at making daggers 'engraved by iron tools with patterns of beautiful

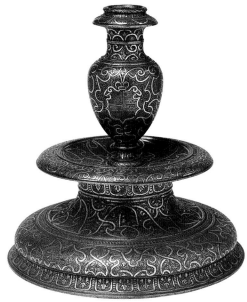

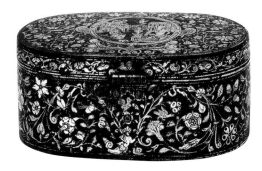

foliage, in the Turkish style, which were nicely filled in with gold'.[111] These artisans attracted commissions from far and wide. Lord Pembroke's inventory of Wilton House in 1561 records: 'Item a tilte Millayne [Milan] armour with his furniture graven and parcell gilte.'[112]

The technique was not confined to northern Italy: 'damaskers' were mentioned in contemporary English accounts. The V&A owns a small English box dated 1579 which belonged to Elizabeth I's favourite, Robert Dudley, Earl of Leicester, and is decorated in similar style (see plate 92).

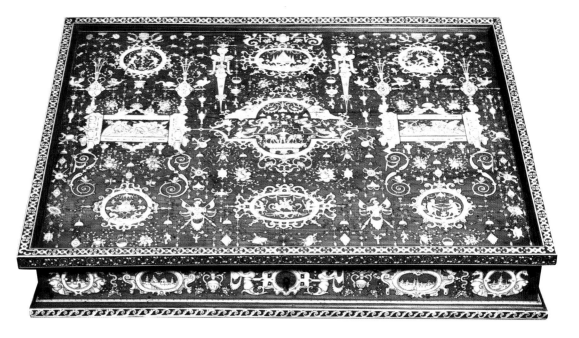

Pl.93, Desk, *c.*1600,
Caspar Lickinger
(possibly), Palazzo
Pesaro, Italy, walnut
inlaid with engraved ivory,
15.2 x 38.1 x 48.26cm,
V&A: W.1-1958. The desk
is inlaid with designs
based on engravings by
Etienne Delaune and
Robert Dumesnil and
bears the arms of
Francesco Maria II,
Duke of Urbino.

BELOW
Pl.94, Games board,
1580–1600, southern
Germany, ebony veneer
inlaid with engraved
bone, 41.5 x 42 x 6.6cm,
V&A: 567-1899

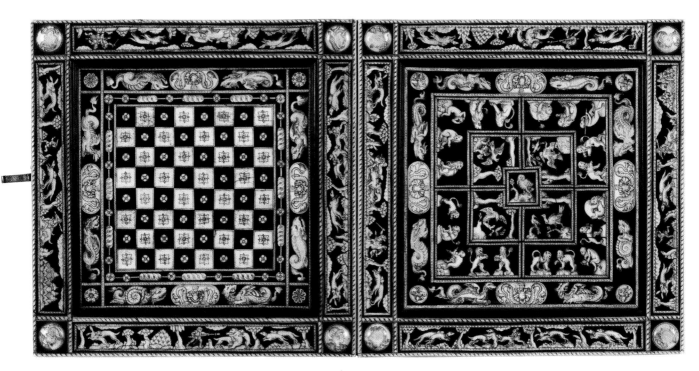

Inlays

Wood inlaid with antler or bone was an expensive luxury. In 1567 a student at the Middle Temple, John Petre, paid 30s for 'a desk of walnutt tree overwrought with white wood, by the Quenes joiner'.[113] An inventory of Ingatestone Hall, north-east of London, in 1600 not only places the walnut bed with inlaid head, fluted posts and gilt knobs, in one of the grandest rooms, the Corner Chamber, but also describes it as hung with crimson, white and gold cloth with silk fringes.[114] Under aristocratic patronage this technique produced items of breathtaking beauty (see plates 93 and 94). The fashion for bone and horn inlays took hold above all in German principalities, but in England, France and the Netherlands, where ivory was used as well, this delicate work was also in vogue.

Some of the most beautiful items decorated this way were also the most deadly: firearms, crossbows and powder flasks. A musket dated 1588 with similar pistol and powder flask originally belonging to Sir William Harris of Shenfield House, Essex, is an extremely rare English ensemble in this style (see plate 95). The inlay of the powder flask is particularly decorative. The scene on the front, a

Pl.95, Pistol and powder flask, c.1580, England, wood inlaid with engraved antler, iron and steel damascened in gold and silver; H: 58cm (pistol); 24.1 x 7.5 x 3.2cm (flask), V&A: M.949 & 950-1983

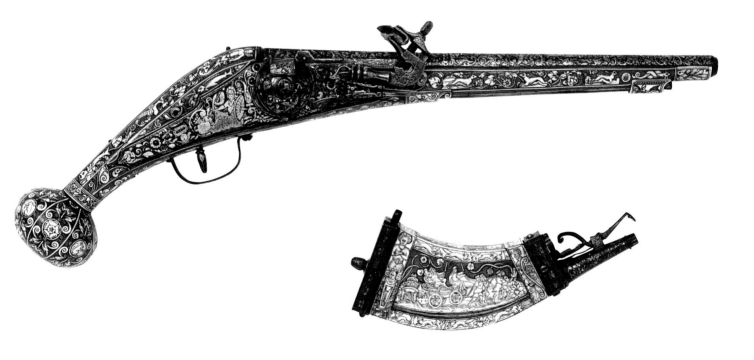

figure in a chariot being drawn by other crowned figures passing a walled city, depicts the classical story of the Triumph of Fame, based on engravings by the Nuremberg artist Virgil Solis.

Fruit, flowers, trophies of arms and strapwork (resembling cut and curled strips of leather) are frequently used as inlay designs, just as they are on wood panelling and plasterwork. Indeed, the effect of contrasting panels of rich walnut with pale bone might also be compared with the effect of decorative half-timbering on houses of the same period. Like the embossed shield, the ornament could be all-encompassing. So detailed is some of this inlay that the wooden background almost vanishes.

Despite the extraordinary level of skill and patience required to carve the channels in the wood and cut and insert the antler, very few practitioners have been identified. Rarely is this work signed, although the antler on the butt of the English musket is marked with the initials 'RI' and 'DI'. Indeed there is conjecture as to whether this process was a bi-product of furniture-making or gunstock-making. Jost Amman's *Book of Trades* (1568) illustrated the 'Rifle butt-maker who mounts the iron rifle barrels (produced by other specialists) in artistically finished butts with inlaid ivory'. Inside a compartment in the lid of a small inlaid box that recently appeared at auction in London, a trade label was printed, MICHAEL IENNIG, NÜRNBERG, above and below an oval frame, inside which was an emblem of two crossed pistols and carving tools.[115]

Inlaid woodwork was expensive. Where house inventories of the sixteenth century may give scant details in their listings of most items, inlays are frequently described so that there can be no doubt about identification. An 'Inventory of the plate, Household Stuff, Pictures &c In Kenelworth Castle taken after the death of Robert, Earl of Leycester, 1588' lists 'A chess-borde of bone and ebanie, with thirtie and fower men to it, in a leather case' and 'A par of tabells of bone inlaid, with divers colors and men to them, in a case of leather.'[116] Inlaid firearms and flasks reflected their owners' status and were kept as much for display as for use. Some have probably never been fired, only admired.

Engraving

Engraving on the metal components of weapons is relatively rare, as etching was a more efficient means of applying widespread linear ornament on non-precious

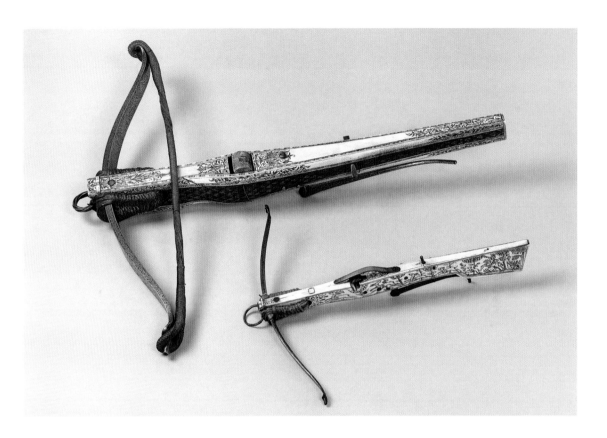

metals. Engraving gold and silver mounts, however, such as the protective collars on sword scabbards, allowed the removed metal to be retrieved and used elsewhere. Engraving was more common on the bone and antler mounts applied to crossbows and guns, with the resulting patterns often inked in black, red or green to increase contrast.

 The tiller of the child's crossbow is entirely covered with antler that has been engraved with hunting scenes, variations of which can be seen in tapestries, on frescoes and on silver dishes (see plate 96). While in war they had been super-seded by firearms by the late sixteenth century, crossbows continued as valued weapons for hunting and target shooting. The Emperor Maximilian I claimed he killed a stag with a crossbow at 200 yards that his companions missed with firearms.[117] Mastering the crossbow remained an essential part of a young gentle-man's education.

Pl.96, Hunting crossbow, c.1600, Germany, etched steel, wood, engraved antler, rope, 68.8 x 64.1 x 12.5cm, V&A: M.2744-1931

The larger, adult crossbow has antler panels engraved and blackened with arabesques, the same treatment accorded the silver-gilt mounts of a prized serpentine tankard (see plate 97). An equally lavishly decorated winch called cranequin, attached to the steel spikes (trunnions) on the side, spanned the chord, and the trigger below released the dart or bolt.

Although crossbow-makers in Germany formed a separate guild, their products represent the coming together of various trades and skills: furniture-maker, horn engraver, armourer and etcher. Just as the tankard, carved by a specialist and fixed with mounts by a goldsmith, was worthy of a place in a cabinet of curiosities, the crossbow, lavishly decorated by several hands, merited its place in an armoury.

Pl.97, Tankard, 1616, Germany, serpentine marble, silver-gilt mounts, 23 x 20.3 x 15cm, V&A: M.975-1928

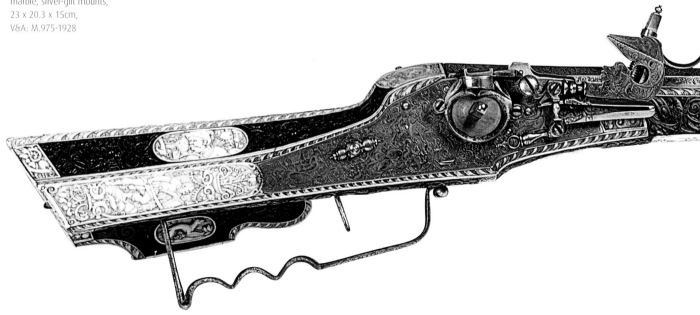

Art and Violence

If there is tension between art and violence for modern eyes, there can be no more an incongruous object than the hunting rifle formerly in Babenhausen Castle near Augsburg (see plate 98). It represents the full flowering of the Renaissance interest in weapons as tasteful fashion statements.

In keeping with contemporary German style, no surface of the gun is left undecorated. The walnut stock is overlaid with ebony carved with interlaced strapwork and bunches of fruit and animals probably derived from Flemish pattern books. The steel wheel-lock is partly gilded and engraved with flowers and figures representing abundance and wealth. This decoration is continued on the barrel where it encloses eight oval panels symbolizing the virtues Temperance, Faith, Fortitude, Truth, Justice, Charity, Humility and Prayer.

Set into the ebony are panels of antler. Some depict hunting scenes, while others show figures of Turkish soldiers based on prints by Amman, a reference to ongoing battles between Christian princes and Muslim communities to the east. Babenhausen belonged to the Fuggers, an extremely wealthy merchant family who bankrolled wars and elections for Habsburg princes. They could well afford such luxuries.

The gun was designed to fire but was primarily a display piece. It shows levels of craftsmanship rarely matched in any medium. It is both killing machine and work of art.

Pl.98, Wheel-lock gun, *c*.1600, Peter Opel (probably), Regensburg, southern Germany, engraved steel, walnut overlaid with carved ebony and ivory, 62.3 x 9.2 x 5.7cm, V&A: M.48-1953

Notes

1 Sydney Anglo, *The Martial Arts of Renaissance Europe* (Yale University Press, New Haven and London, 2000), p.212.

2 William Shakespeare, *King Henry IV*, Part 1, Act 4, Scene 1.

3 For an in-depth study see Clive Wainwright, *The Romantic Interior: The British Collector at Home* (Yale University Press, New Haven and London, 1989).

4 In particular see J.F. Hayward, *Virtuoso Goldsmiths and the Triumph of Mannerism 1540–1620* (Sotheby Parke Bernet, London, 1976), Ch. 16, 'The Goldsmith as Armourer and Base Metal Worker'.

5 *Sporting Glory, The Courage Exhibition of National Trophies at the Victoria and Albert Museum* (Sporting Trophies Exhibitions Ltd., London, 1992), p.176.

6 Audience research by the V&A for the Medieval and Renaissance Galleries Project, Dept of Learning, 2007.

7 Phillip Stubbes, *The Anatomie of Abuses* (London, 1583, National Art Library, Miscellaneous Tracts: temp. Eliz. & Jac. 1, Forster 1857), p.64.

8 Robert Greene, *A Quip for an Upstart Courtier: or, A quaint dispute betweene velvet breeches and cloth breeches Wherein is plainely set downe the disorders in all estates and trades* (London, first printed 1583; reprinted 1620), The Epistle Dedicatory.

9 Janet Armold, *Queen Elizabeth's Wardrobe Unlock'd* (Maney, Leeds, 1988).

10 Giovanni Della Casa, *Galateo of Manners & Behaviours: A Renaissance Courtesy-Book* (First published Venice, 1558; Grant Richards, London, 1914), p.45.

11 Giovanni Della Casa, *Galateo of Manners & Behaviours: A Renaissance Courtesy-Book* (First published Venice, 1558; Grant Richards, London, 1914), p.2.

12 William Shakespeare, *King Henry IV*, Part 1, Act 4, Scene 1.

13 Christian Beaufort and Matthias Pfaffenbichler, *Meisterwerke der Hofjagd- und Rüstkammer, Kunsthistorischesmuseum* (Vienna, 2005), cat. 52, p.152.

14 Toby Capwell, *The Real Fighting Stuff* (Glasgow Museums, 2007), p.40.

15 J.F. Hayward, *European Armour* (London, 1965), cat. 31.

16 Phillip Stubbes, *The Anatomie of Abuses* (London, 1583, National Art Library, Miscellaneous Tracts: temp. Eliz. & Jac. 1, Forster 1857), p.26.

17 *An Inventorie all the gold and sylver plate, jewelles and apparell and warderobe stuffe with the furniture of stable, armorie and all other implementes of householde belonging to the right honorable William, Earle of Pe[m]broke, vewed at the commaundement of the seyd Earl, by the Lorde Harbert of Cardyf his sonne, John Hownde, William Jordan, John Dysteley, Morgan Lloyd, servantes to the said earle, the xiith of December anno domini 1561, Regni Elizabeth Regine quarto*, National Art Library, MS.L.30-1982, f.48r.

18 *An Inventorie all the gold and sylver plate, jewelles and apparell and warderobe stuffe with the furniture of stable, armorie and all other implementes of householde belonging to the right honorable William, Earle of Pe[m]broke, vewed at the commaundement of the seyd Earl, by the Lorde Harbert of Cardyf his sonne, John Hownde, William Jordan, John Dysteley, Morgan Lloyd, servantes to the said earle, the xiith of December anno domini 1561, Regni Elizabeth Regine quarto*, National Art Library, MS.L.30-1982, f.116r.

19 Maria Hayward, *Dress at the Court of King Henry VIII* (Maney, Leeds, 2006), p.330.

20 Stephen V. Grancsay, 'The Mutual Influence of Costume and Armor: A Study of Specimens in the Metropolitan Museum of Art', *Metropolitan Museum Studies*, Vol. 3, No. 2, June 1931, p.195.

21 Sydney Anglo, *The Martial Arts of Renaissance Europe* (Yale University Press, New Haven and London, 2000), p.217.

22 Ingleborg Petrascheck-Heim, 'Tailors' Masterpiece Books', *Costume*, Vol. 3 (London, 1969), p.6.

23 Carole Collier Frick, *Dressing Renaissance Florence: Families, Fortunes, & Fine Clothing* (Johns Hopkins University Press, Baltimore, London, 2002), p.37.

24 Juan de Alcega, *Book of the Practice of Tailoring: Measuring and Marking Out* (Madrid, 1589; translated by Jean Pain & Cecilia Bainton, Bedford, 1979), f.50.

25 Matthias Pfaffenbichler, *Medieval Craftsmen: Armourers* (British Museum Press, London, 1992), p.49.

26 Giovanni Della Casa, *Galateo of Manners & Behaviours: A Renaissance Courtesy-Book* (Grant Richards, London, c.1914), pp.101–2.

27 Juan de Alcega, *Book of the Practice of Tailoring: Measuring and Marking Out* (Madrid, 1589; translated by Jean Pain & Cecilia Bainton, Bedford, 1979), f.v.

28 William Harrison, *The Description of England* (First published 1587; Dover Publications, New York, 1994), p.146.

29 Giovanni Della Casa, *Galateo of Manners & Behaviours: A Renaissance Courtesy-Book* (Grant Richards, London, c.1914), p.105.

30 Sumptuary Law 'The Excess of Apparel ..', Westminster, 7 May 1562, 16 Elizabeth I (transcribed at http://elizabethan.org/sumptuary/index.html, visited 28 November 2008).

31 Amanda Bailey, *Flaunting: Style and the Subversive Male Body in Renaissance England* (University of Toronto Press, 2007), p.26.

32 Kim M. Phillips, 'Masculinities and Medieval English Sumptuary Laws', *Gender History*, Vol. 19, Issue 1, April 2007, p.30.

33 William Shakespeare, *Much Ado About Nothing*, Act 3, Scene 3.

34 For the frequency of proclamations see Alan Hunt, *Governance of the Consuming Passions: A History of Sumptuary Law* (MacMillan, 1996), pp.29–33.

35 Kent Roberts Greenfield, 'Sumptuary Law in Nürnberg: A Study in Paternal Government', *Johns Hopkins University Studies in Historical and Political Science* (Baltimore, 1918), Ch. 8, 'The Regulation of Clothing'.

36 Sumptuary Law 'The Excess of Apparel ..', Greenwich, 15 June 1574, 16 Elizabeth I (transcribed at http://elizabethan.org/sumptuary/index.html, visited 28 November 2008).

37 Mario Scalini, 'The Weapons of Lorenzo de' Medici' in Robert Held (ed.), *Art, Arms and Armour: An International Anthology*, Vol. ?? (Acquafresca Editrice Chiasso, Switzerland, Spring 1979), pp.18–19.

38 *An Inventorie all the gold and sylver plate, jewelles and apparell and warderobe stuffe with the furniture of stable, armorie and all other implementes of householde belonging to the right honorable William, Earle of Pe[m]broke, vewed at the commaundement of the seyd Earl, by the Lorde Harbert of Cardyf his sonne, John Hownde, William Jordan, John Dysteley,*

Morgan Lloyd, servantes to the said earle, the xiith of December anno domini 1561, Regni Elizabeth Regine quarto, National Art Library, MS.L.30-1982, f.51v.

39 Lisa Jardine, *The Awful End of Prince William the Silent: The First Assassination of a Head of State with a Handgun* (HarperCollins, London, 2005), Appendix 5.

40 George Bull (trans.), *The Autobiography of Benvenuto Cellini* (The Folio Society, London, 1966), p.217.

41 Jane Ashelford, *The Art of Dress: Clothes and Society, 1500–1914* (London, 1996), p.20.

42 Frances Elizabeth Baldwin, *Sumptuary Legislation and Personal Regulation in England* (Baltimore 1926), p.221.

43 Kent Roberts Greenfield, 'Sumptuary Law in Nürnberg: A Study in Paternal Government', *Johns Hopkins University Studies in Historical and Political Science* (Baltimore, 1918), p.110.

44 John Martin Vincent, *Costume and Conduct in the Laws of Basel, Bern and Zurich, 1370–1800* (Johns Hopkins Press, 1935), p.46.

45 Mildred Davison, 'Shoes of Our Ancestors', *Bulletin of the Art Institute of Chicago*, Vol. 28, No. 7, December 1934, p.104.

46 François Rabelais, *Gargantua und Pantagruel* (Forgotten Books, 1964), p.36.

47 Aileen Ribeiro, *Dress and Morality* (London, 1986), p.60.

48 Ian Heath, *Armies of the Sixteenth Century* (Foundry Books, St Peter Port, Guernsey, 1997), p.31.

49 A. Denny-Brown, 'Rips and Slits: The Torn Garment and the Medieval Self' in Catherine Richardson (ed.), *Clothing Culture, 1350–1650* (Aldershot: Ashgate, 2004), p.232.

50 A. Denny-Brown, 'Rips and Slits: The Torn Garment and the Medieval Self' in Catherine Richardson (ed.), *Clothing Culture, 1350–1650* (Aldershot: Ashgate, 2004), p.229.

51 A. Denny-Brown, 'Rips and Slits: The Torn Garment and the Medieval Self' in Catherine Richardson (ed.), *Clothing Culture, 1350–1650* (Aldershot: Ashgate, 2004), p.228.

52 *An Inventorie all the gold and sylver plate, jewelles and apparell and warderobe stuffe with the furniture of stable, armorie and all other implementes of householde belonging to the right honorable William, Earle of Pe[m]broke, vewed at the commaundement of the seyd Earl, by the Lorde Harbert of Cardyf his sonne, John Hownde, William Jordan, John Dysteley, Morgan Lloyd, servantes to the said earle, the xiith of December anno domini 1561, Regni Elizabeth Regine quarto*, National Art Library, MS.L.30-1982, f.52v.

53 Giovanni Della Casa, *Galateo of Manners & Behaviours: A Renaissance Courtesy-Book* (Grant Richards, London, *c.*1914), p.102.

54 Giovanni Della Casa, *Galateo of Manners & Behaviours: A Renaissance Courtesy-Book* (Grant Richards, London, *c.*1914), pp.106–7.

55 Phillip Stubbes, *The Anatomie of Abuses* (London, 1583, National Art Library, Miscellaneous Tracts temp. Eliz. & Jac. 1, Forster 1857), pp.56–7.

56 Angus Patterson and Fergus Cannan, *Arms and Armour at the Middle Temple*, The Middle Templar, Issue 42, Summer 2007, and Issue 43, Winter 2007.

57 Sydney Anglo, *The Martial Arts of Renaissance Europe* (Yale University Press, New Haven and London, 2000), p.217.

58 Jane Ashelford, *The Art of Dress: Clothes and Society, 1500–1914* (London, 1996), p.31.

59 Susan North, ' "An Instrument of profit, pleasure and ornament": Embroidered Tudor and Stuart Dress Accessories' (**Yet to be published**)

60 William Shakespeare, *Much Ado About Nothing*, Act 3, Scene 3.

61 William Shakespeare, *The Merchant of Venice*, Act 1, Scene 2.

62 Aileen Ribeiro, *Dress and Morality* (London, 1986), p.68.

63 George Silver, *Paradoxes of Defence* (Edward Blount, London, 1599) in Cyril G.R. Matthey, *The Works of George Silver* (George Bell & Sons, Covent Garden, 1898), The Epistle Dedicatorie.

64 For a fuller discussion of the evolution of the sword see Donald J. LaRocca, 'The Renaissance Spirit' in Victor Harris et al, *Swords and Hilt Weapons* (Barnes and Noble Books, New York, 1993).

65 Sydney Anglo, *The Martial Arts of Renaissance Europe* (Yale University Press, New Haven and London, 2000), p.144.

66 Peter and Ann Mactaggart, 'The Rich Wearing Apparel of Richard, 3rd Earl of Dorset', *Costume*, Vol. 14, London, 1980, pp.50–53.

67 Jane Ashelford, *The Art of Dress: Clothes and Society, 1500–1914* (London, 1996), pp.28, 37.

68 For a fuller analysis see Susan Vincent, *Dressing the Elite: Clothes in Early Modern England* (Oxford, 2003), Ch. 3.

69 Ann Rosalind Jones and Peter Stallybrass, *Renaissance Clothing and the Materials of Memory* (Cambridge University Press, 2000), p.34.

70 Abraham Lopez, *Alonso Perez, Swordmaker of Toledo* (The Institute of Marine Archaeology Conservation website: http://www.imacdigest.com/Toledo.htm, visited December 2008).

71 Robert Greene, *A Quip for an Upstart Courtier: or, A quaint dispute betweene velvet breeches and cloth breeches Wherein is plainely set downe the disorders in all estates and trades* (London, first printed 1583; reprinted 1620), p.12.

72 J.F. Hayward, *Virtuoso Goldsmiths and the Triumph of Mannerism 1540–1620* (Sotheby Parke Bernet, London, 1976), p.319.

73 Malcolm Wanklyn, *Inventories of Worcestershire Landed Gentry 1537–1786*, Worcestershire Historical Society, New Series, Vol. 16, 'William Gower of Wood Hall in Norton-Juxta-Kempsey, Esquire, 1566', p.37.

74 Baldassare Castiglione, *The Book of the Courtier* (First published 1528; Courier Dover Publications, 2003).

75 Hans Talhoffer, *Medieval Combat* (First published 1467; translated and edited by Mark Rector, Greenhill Books, London, 2004), p.11.

76 Vincentio Saviolo, *Discourse of Rapier and Dagger, In two Bookes. The first intreating of the use of the Rapier and Dagger. The second, of Honor and honourable Quarrels* (John Wolfe, London, 1595), p.7.

77 George Silver, *Paradoxes of Defence* (Edward Blount, London, 1599) in Cyril G.R. Matthey, *The Works of George Silver* (George Bell & Sons, Covent Garden, 1898), p.25.

78 Sydney Anglo, *The Martial Arts of Renaissance Europe* (Yale University Press, New Haven and London, 2000), p.281.

79 George Silver, *Paradoxes of Defence* (Edward Blount, London, 1599) in Cyril G.R. Matthey, *The Works of George Silver* (George Bell & Sons, Covent Garden, 1898), The Epistle Dedicatorie, and p.9.

80 William Harrison, *The Description of England* (First published 1587; Dover Publications, New York, 1994), p.237.

81 George Silver, *Paradoxes of Defence* (Edward Blount, London, 1599) in Cyril G.R. Matthey, *The Works of George Silver* (George Bell & Sons, Covent Garden, 1898), The Epistle Dedicatorie.

82 Sydney Anglo, *The Martial Arts of Renaissance Europe* (Yale University Press, New Haven and London, 2000), p.36.

83 Sumptuary Law 'The Excess of Apparel ..', Westminster, 6 May 1562, 16 Elizabeth I (transcribed at http://elizabethan.org/sumptuary/index.html, visited 28 November 2008).

84 Sumptuary Law 'The Excess of Apparel ..', Westminster, 15 June 1574, 16 Elizabeth I (transcribed at http://elizabethan.org/sumptuary/index.html, visited 28 November 2008).

85 John Stow, *The annales, or, Generall chronicle of England begun first by maister Iohn Stow; and after him continued and augmented with matters forreyne and domestique, auncient and moderne, vnto the ende of this present yeere 1614 by Edmond Howes* (Thomas Adams, London, 1615), p.869.

86 Sydney Anglo, *The Martial Arts of Renaissance Europe* (Yale University Press, New Haven and London, 2000), p.99.

87 Phillip Stubbes, *The Anatomie of Abuses* (London, 1583, National Art Library, Miscellaneous Tracts: temp. Eliz. & Jac. 1, Forster 1857), p.xiii.

88 Robert Greene, 'The Scottish History of James the Fourth' (London, 1598), in Alexander Dyce (ed.) *The Dramatic and Poetical Works of Robert Greene and George Peele* (Routledge, London, 1861), Act 4, Scene 1.

89 Robert Greene, *A Quip for an Upstart Courtier: or, A quaint dispute betweene velvet breeches and cloth breeches Wherein is plainely set downe the disorders in all estates and trades* (London, first printed 1583; reprinted 1620).

90 Thomas F. Arnold, *The Renaissance at War* (Cassell & Co., London, 2001), p.100.

91 William Harrison, *The Description of England* (First published 1587; Dover Publications, New York, 1994), p.238.

92 Lisa Jardine, *The Awful End of Prince William the Silent: The First Assassination of a Head of State with a Handgun* (HarperCollins, London, 2005), p.93.

93 Lisa Jardine, *The Awful End of Prince William the Silent: The First Assassination of a Head of State with a Handgun* (HarperCollins, London, 2005), Appendix 5.

94 For a fuller, illustrated account see Alfred Auer, Veronika Sandbichler, Karl Schütz and Christian Beaufort-Spontin, *Ambras Castle* (Kunsthistorischesmuseum, Vienna, 2000).

95 Mario Scalini, 'The Weapons of Lorenzo de' Medici' in Robert Held (ed.), *Art, Arms and Armour: An International Anthology*, Vol. ?? (Acquafresca Editrice Chiasso, Switzerland, Spring 1979), p.13.

96 Dirk Syndram and Antje Scherner (eds), *Princely Splendor: The Dresden Court 1580–1620* (Staatliche Kunstammlungen, Dresden, 2004), pp.74–9.

97 Dirk Syndram and Antje Scherner (eds), *Princely Splendor: The Dresden Court 1580–1620* (Staatliche Kunstammlungen, Dresden, 2004), p.72.

98 Alfred Auer, Veronika Sandbichler, Karl Schütz and Christian Beaufort-Spontin, *Ambras Castle* (Kunsthistorischesmuseum, Vienna, 2000), pp.20–21.

99 Dirk Syndram and Antje Scherner (eds), *Princely Splendor: The Dresden Court 1580–1620* (Staatliche Kunstammlungen, Dresden, 2004), p.72.

100 William Harrison, *The Description of England* (First published 1587; Dover Publications, New York, 1994), p.237.

101 Malcolm Wanklyn, *Inventories of Worcestershire Landed Gentry 1537–1786*, Worcestershire Historical Society, New Series, Vol. 16, 'Leonard Jefferies of Earls Croome, Esquire, 1629', p.151.

102 Malcolm Wanklyn, *Inventories of Worcestershire Landed Gentry 1537–1786*, Worcestershire Historical Society, New Series, Vol. 16, 'Sir Thomas Bigge of Lenchwick, Knight, 1621', p.142.

103 José Godoy and Silvio Leydi, *Parures Triomphales: Le Maniérisme dans l'Art de l'Armure Italienne* (Geneva: Musées d'Art et d'Histoire, 2003), pp.480–87.

104 William Harrison, *The Description of England* (First published 1587; Dover Publications, New York, 1994), p.237.

105 J.F. Hayward, *Virtuoso Goldsmiths and the Triumph of Mannerism 1540–1620* (Sotheby Parke Bernet, London, 1976), Ch. 16: 'The Goldsmith as Armourer and Base Metal Worker'.

106 Susan North, ' "An Instrument of profit, pleasure and ornament": Embroidered Tudor and Stuart Dress Accessories' (Yet to be published)

107 For a fuller analysis see Stuart Pyhrr and Thom Richardson, 'The Master of the Snails and Dragonflies Identified', *Journal of the Arms and Armour Society*, Vol. XIV, No. 6, September 1994.

108 Dirk Syndram and Antje Scherner (eds), *Princely Splendor: The Dresden Court 1580–1620* (Staatliche Kunstammlungen, Dresden, 2004), p.172.

109 J.F. Hayward, 'The Sigman Shield', *Journal of the Arms and Armour Society*, London, Vol.II, 1956–8, pp.21–42.

110 Stuart W. Pyhrr and José-A Godoy, *Heroic Armor of the Italian Renaissance – Filippo Negroli And His Contemporaries* (Metropolitan Museum of Art, New York, 1999), p.284.

111 George Bull (trans.), *The Autobiography of Benvenuto Cellini* (The Folio Society, London, 1966), p.56.

112 *An Inventorie all the gold and sylver plate, jewelles and apparell and wardrobe stuffe with the furniture of stable, armorie and all other implementes of householde belonging to the right honorable William, Earle of Pe[m]broke, vewed at the commaundement of the seyd Earl, by the Lorde Harbert of Cardyf his sonne, John Hownde, William Jordan, John Dysteley, Morgan Lloyd, servantes to the said earle, the xiith of December anno domini 1561, Regni Elizabeth Regine quarto*, National Art Library, MS.L.30-1982, f.116r.

113 *Ingatestone Hall in 1600, An Inventory*, Essex Education Committee, 1954, p.4.

114 *Ingatestone Hall in 1600, An Inventory*, Essex Education Committee, 1954, p.12.

115 Sale Catalogue, *Fine Antique Arms and Armour from the Henk L. Visser Collection*, Bonhams, Knightsbridge, London, 28 November 2007, lot 156.

116 An Inventory of the Plate, Household Stuff, Pictures, &c In Kenelworth Castle, taken after the death of Robert Earl of Leycester, 1588 (19th-century transcript, National Art Library).

117 Howard Blackmore, *Hunting Weapons* (Barrie & Jenkins, London, 1971), p.216.

Glossary

Astrolabe
An instrument for making calculations in astronomy and astrology, such as the times of sunrise and sunset, the rising and setting times for stars, and the configuration of the heavens for a time in the future or past.

Burnished
Polished by friction with a hard, smooth tool to a bright lustre.

Cuisses
Armour for the front part of the thighs.

Garniture
A set or ensemble, including a full armour plus pieces to exchange for different roles.

Gauntlet
A glove usually made of steel, or leather covered in plates of steel.

Gilding/Gilt/Parcel-gilt
A coating of gold. When applied to armour, gilding is usually done by painting a paste of powdered gold and mercury onto the surface and then burning off the mercury (fire-gilding). Parcel-gilt means partly gilt.

Gorget
A piece of armour protecting the neck and throat. By the late sixteenth century a gorget was also a collar of cloth worn by both men and women.

Greaves
Armour for the lower legs.

Hose/Trunk-hose
Clothing for the legs. Trunk-hose were bulbous and often padded to alter the wearer's silhouette and display large amounts of fabric.

Jerkin
A tight-fitting jacket, often of leather, worn by men.

Leg-harness
Collective term for a set of leg armour.

Mace
A metal club often with spiked blades. By the mid seventeenth century it had evolved from a war weapon designed to tear armour to a grand ceremonial emblem of royal or civic authority.

Mail
Often erroneously referred to as 'chain-mail'. 'Mail' comes from the Latin 'macula', meaning a net or web. Mail coats and shirts were made from interlinked metal loops that might be worn under civilian clothing or with armour.

Morion
A tall, conical, brimmed helmet worn by guards and foot soldiers.

Murderinge Peece
This rarely used term may refer to a small cannon or mortar.

Musket
A long-barrelled infantry gun with a smooth-bore that fired a lead ball. Muskets were fired from the shoulder or rested on a stand.

Pauldrons
Armour covering the shoulders.

Petronel
A long gun held with its curved butt-plate pressed against the chest to resist recoil. With its heavy stock and long barrel it required a gun-rest for accuracy.

Pollaxe
A weapon usually with an axe blade or hammer head, or combination of both, used in close combat.

Pommel
The rounded knob at the end of a sword-hilt.

Poulaines
The long pointed toes on shoes of the mid to late fifteenth century.

Priming Flask
A small flask that dispensed fine gunpowder into the ignition pan of a gun's firing mechanism.

Ruff
Ornamental collar, usually of starched linen, particularly popular during the late sixteenth and early seventeenth centuries.

Sabatons
Armour for the feet.

Sabre
A sword with a slightly curved blade and single cutting edge used for both slashing and thrusting.

Skayne/Skean
A type of short dagger with a straight double edge that originated in Ireland. By the seventeenth century the term was used to refer to any short dagger.

Spurs
A small spike or spiked wheel attached to the heel for pricking a horse into action.

Target
A light, round shield for use in combination with swords and daggers.

Tassets
Armour to protect the hips and thighs.

Vambrace
Armour for the forearm.

Further Reading

Anglo, Sydney, *The Martial Arts of Renaissance Europe* (Yale University Press, New Haven and London, 2000)

Arnold, Thomas F., *The Renaissance at War* (Cassell & Co., London, 2001)

Ashelford, Jane, *The Art of Dress: Clothes and Society*, 1500–1914 (London, 1996)

Bailey, Amanda, *Flaunting: Style and the Subversive Male Body in Renaissance England* (University of Toronto Press, 2007)

Capwell, Tobias, *The Real Fighting Stuff* (Glasgow Museums, 2007)

Hayward, Maria, *Dress at the Court of King Henry VIII* (Maney, Leeds, 2006)

Pfaffenbichler, Matthias, *Medieval Craftsmen: Armourers* (British Museum Press, London, 1992)

Pyhrr, Stuart W. and Godoy, José-A, *Heroic Armor of the Italian Renaissance – Filippo Negroli and His Contemporaries* (Metropolitan Museum of Art, New York, 1999)

Ribeiro, Aileen, *Dress and Morality* (London, 1986)

Syndram, Dirk and Scherner, Antje (eds), *Princely Splendor: The Dresden Court 1580–1620* (Staatliche Kunstammlungen, Dresden, 2004)

Further Places to see Historic Armour and Clothing

Dresden Armoury, Semperbau am Zwinger, Dresden, Germany

Hofjagd- und Rüstkammer, Neue Burg, Vienna

Musée de L'Armée, Hotel des Invalides, Paris, France

Real Armeria, Madrid, Spain

Schloss Ambras, Innsbruck, Austria

The Fitzwilliam Museum, Cambridge, UK

The Metropolitan Museum of Art, New York, USA

The Royal Armouries, Leeds, UK

The Wallace Collection, London, UK

Zeughaus, Graz, Austria

Acknowledgements

This book is dedicated to Anthony RE North.

My sincere thanks go to Leslie Fitzpatrick, intern extraordinaire, for her tireless research and wealth of ideas. My attempt to place armour and weapons in the context of fashion and art history has drawn on the knowledge and support of many specialists in a range of related fields and exposed the text to wide scrutiny. I am particularly grateful to the following readers for their helpful comments and corrections: Dr Christopher Breward (Head of Research, V&A), Dr Tobias Capwell (Curator of Arms and Armour, Wallace Collection, London), Dr Richard Edgcumbe (Senior Curator, Metalwork Collection, V&A), Philippa Glanville (former Head of Metalwork, V&A), Elizabeth Miller (Deputy Head of Research, V&A), Lesley Miller (Senior Curator, Textiles & Fashion, V&A), Angela McShane (Tutor in Graduate Studies, V&A Royal College of Art), Peta Motture (Chief Curator, Medieval & Renaissance Galleries Project, V&A), Anthony RE North (former Curator of Base Metals and Arms and Armour, V&A), Susan North (Curator of Textiles & Fashion, V&A), Lucy Trench (interpretation Editor, V&A), Simon Metcalf (Armourer and Senior Metalwork Conservator, Royal Collection, London), Dr Paul Williamson and Dr Tessa Murdoch (respectively Keeper and Deputy Keeper of the Dept. of Sculpture, Metalwork, Ceramics & Glass, V&A).

Many people provided extremely useful suggestions and help throughout the preparation of the book. My thanks go to Fergus Cannan, Thomas Del Mar, Debra Dreger, Peter Finer, Redmond Finer, James Green, Victoria Harris, Fiona Hawkins, Julian Holland, Ethan Kalemjian, David Longfield, Helen Patterson, Eric Turner, Rowan Watson, Lesley Whitelaw. I am especially grateful to Stuart Pyhrr and Donald J. LaRocca of the Department of Arms and Armor, Metropolitan Museum of Art, New York, for their time and knowledge.

For the many new photographs I thank Richard Davis, Pip Barnard and Christine Smith and for servicing the photography programme I thank my colleagues Louise Hofman, Carmen Holdsworth-Delgado, Sophie Leighton, Stephanie Seavers, Katy Temple, Heike Zech.

The Publishing Department at the V&A has also been highly supportive, namely Anjali Bulley, Mark Eastment and Laura Potter. I would like to thank Rachel Malig for her patient and understanding editorial service and Andrew Shoolbred for the design.

The book is one of several publications launched with the Museum's new Medieval & Renaissance Galleries. I am particularly grateful to Kirstin Kennedy, lead curator of the Renaissance displays, who first suggested a book on an often understated area of the collection.

Picture Credits

Index

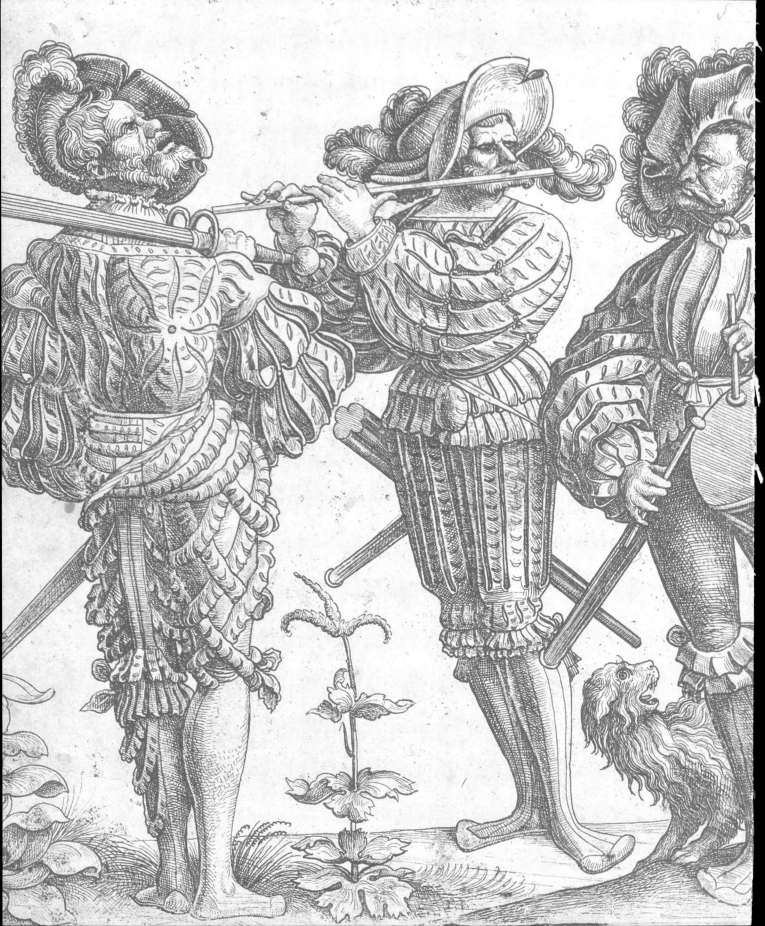